ANSEL ADAMS IN COLOR

ANSEL ADAMS

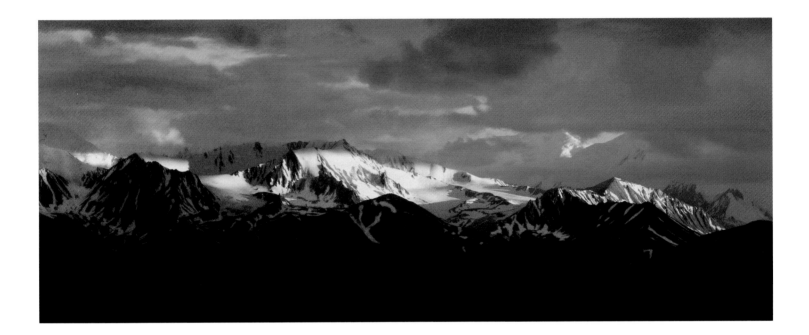

IN COLOR

Edited by Harry M. Callahan

With John P. Schaefer and Andrea G. Stillman
Introduction by James L. Enyeart
Selected Writings on Color Photography by Ansel Adams

LITTLE, BROWN AND COMPANY
BOSTON NEW YORK TORONTO LONDON

Frontispiece: Detail of the Alaska Range, Denali National Park, Alaska, 1948

Copyright ©1993 by the Trustees of The Ansel Adams Publishing Rights Trust
Editor's Note copyright ©1993 by Harry M. Callahan

First Edition

LIBRARY OF CONGRESS CATALOGING-IN-PUBLICATION DATA

Adams, Ansel, 1902–1984
Ansel Adams in color / edited by Harry M. Callahan: with John P. Schaefer
and Andrea G. Stillman: introduction by James L. Enyeart: selected writings on color
by Ansel Adams — 1st ed.
p. cm.
ISBN 0-8212-1980-4
1. Color photography. I. Callahan, Harry M. II. Schaefer, John Paul.
III. Stillman, Andrea Gray. IV. Title.
TR510.A3 1993 779'.092–dc20 92-46502

Published simultaneously in Canada by Little, Brown & Company (Canada) Limited

PRINTED IN THE UNITED STATES OF AMERICA

Contents

Editor's Note . 7

Introduction: Quest for Color 9

Portfolio . 33

Selected Writings on Color Photography by Ansel Adams . . . 117

List of Plates . 130

Technical Note . 131

Acknowledgments 132

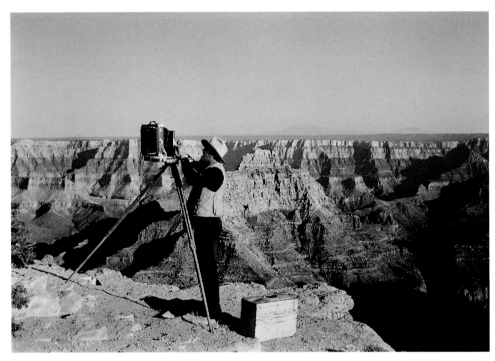

Ansel Adams photographing at the Grand Canyon, Arizona, 1950 (by George L. Waters)

Editor's Note

I started photography in 1938 as a hobby and was fascinated, learning technique slowly from friends and camera clubs. In 1941, when I had become frustrated with my photographs, Ansel Adams happened to come to our Detroit Camera Club. He had an exhibit of maybe forty photographs, mostly contact prints: 4 x 5, 5 x 7, 8 x 10 and a couple of 11 x 14-inch enlargements. These photographs were so sharp and brilliant that they were a revelation to me. That to me was photography. While I liked the spectacular scenes, the close-up pictures, mainly of nature, meant the most to me. I had been out west and had photographed the mountains with poor results. Unconsciously, I realized that I could make fine photographs with ordinary subject matter.

A week later Ansel came back and took us on a field trip. After a while people drifted off, and Ansel was alone. I asked if he would mind answering some technical questions. He said he would be glad to be doing something. He graciously answered all of my questions about lenses, paper, film developers, etc.

Ansel talked with reverence about classical music and Stieglitz. So, I started collecting classical records and reading all I could about Stieglitz. I was powerfully moved by the music and what I learned about Stieglitz and his following. This was my first real introduction to fine art. I was inspired by Stieglitz's photographs and writings and eventually went to New York to see him. It was a slightly difficult experience but very worthwhile.

I remember reading that Ansel said working with color was like playing on an off-key piano. I also remember Paul Strand complaining about the modern photo papers in comparison to platinum paper. Of course, he adjusted to the new. I think if Ansel could have gotten good prints from his color transparencies he would have been more excited about them.

Choosing the transparencies for this book was a great experience for me. I particularly liked the Grand Canyon group. They are beautiful pictures — not tourist-type pictures. They are an artist's pictures. When I came back from Carmel after selecting the transparencies, I thought, "Ansel's got big trees, a big ocean, a big darkroom, and a big following." He really was larger than life — a spectacular guy.

— Harry M. Callahan
October 1992

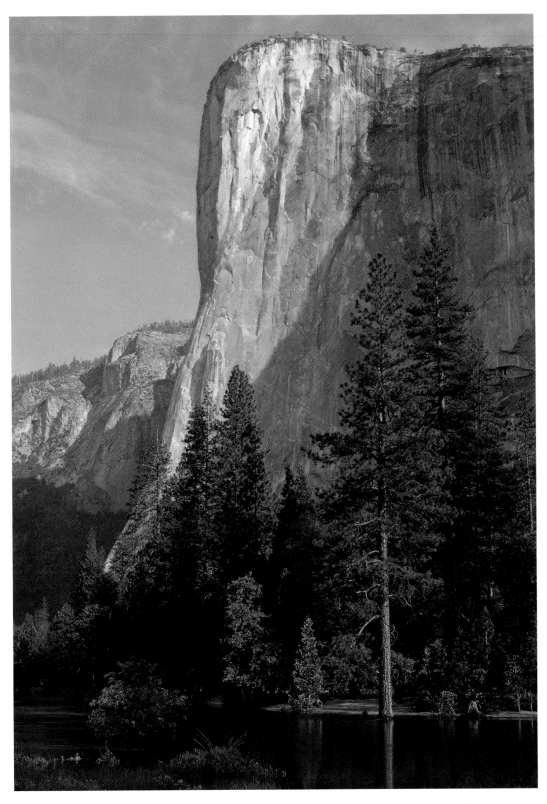

El Capitan, Sunrise, Yosemite National Park, California, 1952

QUEST FOR COLOR

BY JAMES L. ENYEART

It will be of no little surprise to the public and scholars alike that Ansel Adams made more than three thousand color transparencies. He is, of course, known for his black-and-white photography — elegant, silver-laden tableaux of nature — which changed American landscape photography from being essentially documentary and derivative of nineteenth-century painting to an expression of purely photographic drama and effect. His unique vision and technical virtuosity inspired a school of followers — students, imitators, and admirers — who make up the largest, most coherent photographic audience of this century.

However, what remains largely unknown to the public is the extent of Ansel Adams' involvement with color photography. He actively and persistently explored color for over forty years. He not only made photographs in the form of color transparencies, but also published articles on color, exhibited a selection of prints in the exhibition "Color Photography" in 1950 at the Museum of Modern Art, and left nearly two hundred pages of letters and notes on his philosophy of color photography. It was his belief that color would become, along with electronic imaging, the medium of the future.[1] It had been his intention to produce a book on the aesthetics of color, the fifth volume in his technical series, though he denied it would be a technical book. The notes and letters quoted here were drafted by Adams with that book in mind. Thus, while most of his involvement with color, with the exception of commercial assignments, remained unknown to the public, Adams developed within the privacy of his own studio an appreciation for color as an art form.

In one version of a draft introduction to the planned color book (1978), Adams explained his basic reason for publicly addressing his concerns for color photography so late in life:

I should state here that most of my readers do not think of me as being a color photographer. In fact, I have given the impression of being hostile towards it. During my professional years I did a lot of work with Kodachrome. I never engaged in color printing, but I did concern myself with printing press reproductions. Were I entering photography now as a young

man I undoubtedly would deeply concern myself with color. I stayed with black-and-white simply because I enjoyed the controls the process offered. However, I feel strongly that color photography is one of the major expressions of our time. I have applied visualization and the zone system to a great variety of color images and I find both are compatible and effective.[2]

Yet his ongoing quest to apprehend color as a medium of personal expression and his sometimes optimistic statements about color represent only part of the story. Color presented three issues of artistic concern that plagued Adams throughout his life: reality, control, and aesthetics. Each in its own way prevented him from ever fully engaging the medium as an artistic endeavor. These concerns are examined in depth in the text that follows. Moreover, Adams maintained deep feelings of self-doubt in respect to his own color efforts. Late in his life he wrote:

I have done no color of consequence for thirty years! I have a problem with color — I cannot adjust to the limited controls of values and colors. With black-and-white I feel free and confident of results.

However, I have done some color in the past which is acceptable. . . . The Kodachromes have lasted the best of all. I am perplexed over what to do about the good transparencies, as some are worthy of preservation.[3]

It is the intention of this book to present Ansel Adams' unpublished color legacy. This essay provides a historical context for understanding Adams' experiments with the medium of color photography, and, to the extent that appreciation for his work is also gained, the history of photography is better served.

Considering all that has occurred in color photography since Adams' death in 1984, our eyes may be more accepting and understanding of his work than his were in his own time. Adams was plagued with a neverending search for confidence in his own color images, even though he recognized the accomplishments of others. It was decided, therefore, that it would be appropriate to invite a fellow artist, one of his peers, to select examples of his color work for reproduction — to hold up a mirror, as it were, to history.

Harry Callahan, a photographer of Adams' generation (he is now eighty) who has often expressed the debt he owes to Adams in terms of his own work, enthusiastically accepted an invitation to apply his visual sensibilities to this task.[4] Esteemed as one of America's greatest visual poets and admired for his color and black-and-white work, Callahan is a virtual magician in selecting from the world at large objects of significance and recreating their scale, light, and position so that they become altogether new visions of reality.

It was, after all, an altered reality that had moved him in 1941 when he first saw Adams' black-and-white landscape photographs. Even more important, he gained an appreciation of technical control, which Adams provided in his Detroit lecture of that year and in subsequent meetings whenever Callahan

needed to test a technical idea. When he saw Adams' prints for the first time and heard his explanation of process, Callahan realized fully that he too would be able to make prints that would satisfy his own aesthetic desires and abilities.[5]

Callahan readily agreed to apply his keen visual perception, "what looks good" in his words, to making this selection of Adams' photographs. Adams did not consider his many commercial works to be part of his personal creations, so the selection was limited to the landscapes that he had produced for his own pleasure and satisfaction. Callahan selected the fifty works in this book from nearly a thousand transparencies. His method was intuitive and straightforward; he described it as "selecting those things that pleased me." And this is as it should be between one artist and another. If color in one image had slightly shifted through the years this was of no concern to Callahan. He responded to his task as a contemporary artist — visually — without justification, adjustments for historical reasons, or concern for what the image might once have looked like. The task before him, as he saw it, was to select the best pictures according to what his eye had taught him over the past fifty years.

Callahan never involved himself in Adams' philosophical defense of not making color photographic prints or, for that matter, his photographic philosophizing in general. He admired much of Adams' work, and that was sufficient reason for his aesthetic interests; he did not need nor did he want explanation of the creative process.

Callahan could accept the idea that Adams chose never to make prints from his color work, especially in view of the limitations and changes in materials over the years. Just as artists like Adams and Callahan were beginning to explore the aesthetic value of color with confidence, their primary choice of materials began to disappear. Dye-transfer printing, which required three separation negatives (one for each primary color of cyan, magenta, and yellow), allowed a considerable amount of control. Three relief matrices made from the separation negatives were dyed and transferred to a photographic paper base, resulting in rich, saturated color prints. Adams experimented in one or two cases with it, but Callahan produced a substantial body of color work by this process. Unfortunately, dye-transfer was no longer widely available by the mid-1980s.

Callahan felt about dye-transfer printing the same way that Paul Strand felt about platinum prints: once the ideal process was no longer possible, then one's judgment of quality had to be based solely on content. The loss of a print's unique visual appearance, its *syntax*, produced by a particular technique like dye-transfer eroded the base of its particular color aesthetic. Both artists tried a few other color printing techniques but without satisfaction. Callahan, therefore, looked at Adams' color trans-

Unidentified, hand-colored daguerreotype, sixth plate
(8.2 x 7.0 cm.), American, c. 1850, International Museum of
Photography at George Eastman House

parencies in the same way. He selected images based on their content without concern for what they
might have been as color prints.

In order to appreciate Adams' work in color and his seemingly contradictory feelings of appre-
hension of and attraction to the medium, some background information is necessary. Hence, let us probe
briefly into the history of color photography and then examine Adams' actual involvement with color,
and his fundamental artistic concerns.

Prevailing attitudes about color photography before and during Adams' career played an important
role in fostering his reticence toward, and his simultaneous desire to master, what he called
"a beguiling medium."[6]

From as early as 1843 Henry Fox Talbot had offered through his photographic establishment
in Reading and in his London studio hand-colored calotypes of both portraits and scenes. He sold them
for twice the cost of a print in its original monochrome form. But Talbot was not enthusiastic about
the results.[7]

Hand coloring of photographs, including cartes de visite and cabinet cards of the 1850s and
1860s, not to mention daguerreotypes, was part of the commercial bias that condescended to a public
desire for natural color images. But like Talbot, those interested in the aesthetic potential of the medium

had less than enthusiastic thoughts about the introduction of such color. J. H. Croucher, an American photographer, made the following statement in an 1853 book about the daguerreotype process:

While it is true that a little colour may relieve the dark metallic look of some daguerreotypes, it must not be concealed that the covering of the fine delicate outlines and exquisite gradations of tone of a good picture with such a coating [hand tinting] is barbarous and inartistic. The prevailing taste is, however, decidedly for coloured proofs, and the following directions will assist the amateur in ministering to this perverted taste, should he be so inclined.[8]

Croucher presaged the sentiments of most photographers who practiced conventional monochrome photography as an art form well into the last quarter of the twentieth century.

In a similar vein the issue of the public's attraction to colored images centered on the curious debate photographers have always had among themselves about their medium, that of reality. To the general public, photography has always represented a means of capturing reality, and color serves only to enhance the illusion. For photographers, photography has historically been either a vessel of truth (documentary) or an abstraction (personal interpretation), but it has never been confused with reality. Color seemed to beg the question of reality for both the public and photographers.

Adams' own statements reflect the ongoing prejudice and fear of color photography among the medium's practitioners well into our century. Exactly one hundred and thirty years after the condemnation of coloring photographs by Croucher, Adams wrote an elaborate statement on the same subject, found in notes written on March 22, 1983.[9]

Color photography is a beguiling medium in that it offers some apparent simulation of reality, to which the majority of the public respond. Because of economic necessity, the development of color has been keyed to popular demand (much more than black-and-white photography), and the approach to professional work has focused on "realism" of color and fail-safe technology.

The taste-makers in color photography are the manufacturers, advertisers in general and the public with their insatiable appetite for the "snappy snapshot." I have come to the conclusion that the understanding and appreciation of color involves: 1. The illusion that the color photograph represents the colors of the world as we think we perceive them to be. The images are, at best, poor simulations, but the perceptive alchemy translates the two-dimensional picture into the common world of experience. Picture reality is a philosophical and psychological impossibility. 2. Color pictures are so ubiquitous that the casual viewer comes to accept them as the true "reality"; the color process reveals for them the real world, which is not hard to understand because the "real world" is, for most people, an artifact of the industrial/material surround. The colors of the urban environment are for the most part far more garish and "unrelated" than we find in nature. The Creator did not go to art school and natural color, while more gentle and subtle, seldom has what we call aesthetic resonance.

Color is seen as a debased desire on the part of an unknowing public, who values a semblance of reality over the personal vision of a photographer expressed in black-and-white. Aesthetic judgment held little sway over the magic and mystery of an illusion that looked just like things seemed to be in life, no matter how ordinary. The photographer was left with the inevitable pain of knowing that the majority of people could not appreciate "the fine delicate outlines and exquisite gradations of tone" in 1853 and 1983 alike.

The first actual color photographic process, as opposed to hand coloring of photographs, that approximates the technology we know today and that Adams experienced in his time was published as a theory by Clerk Maxwell (a Scotsman) in 1855. It was, however, a Frenchman, Louis Ducos du Hauron, who put theory to practice and produced examples as part of the publication of his own color process in 1869. Ducos du Hauron gave to black-and-white photography the original color process of mixing colors by using filters, a technical manifestation of his desire to achieve color separations for book illustration and for reproductions of works of art.

Ducos du Hauron's invention of the color separation process failed commercially for a variety of reasons, but it inspired a rapid sequence of improvements.[10] In 1880 Charles Cros (also French) published a method of making color prints (imbibition) that is considered the precursor to modern dye-transfer color printing, which until its recent demise was itself the preferred printing process by artists. In 1892 an American, Frederick Ives, developed an apparatus called the Kromstop, which resembled a stereo viewer, to view simultaneously three color-separation negatives through a mirrored sequence, resulting in a full-color image. It was reported to have been "invaluable for evening parties, at homes, conversations, garden parties, etc. and is the most beautiful invention of the nineteenth century."[11]

From the first hand-colored prints and daguerreotypes to various inventions and improvements in color photography at the end of the nineteenth century, color was enthusiastically received only by the public and then for the wrong reasons, according to photographers. The public sought pastimes and entertainment that increased the illusion of reality as a curiosity. Photographers of serious aesthetic intent developed an innate prejudice against color photography over time that lasted well into the latter part of the twentieth century. This attitude and desensitization to color in photography had residual effects on most photographers, including Adams, and created a crisis of confidence that was only finally resolved in the 1970s for creative photography.

Just after the turn of the century there appeared for a brief period a new color process that raised hopes for truly aesthetic possibilities. The Lumière brothers in France announced in 1904 the Auto-

chrome process, which created the equivalent of a color transparency on glass, usually within a 4 x 5-inch camera format. The colors were vivid, yet were separated by delicate soft edges created by the slightly granular texture of the emulsion.

No less than Adams' greatest aesthetic mentor, Alfred Stieglitz, declared the new medium a marvel and a success: "Gentlemen, color photography is now an established fact." Stieglitz is reported to have spoken these words as he introduced a special demonstration of the process on September 27, 1907, in his gallery at 291 Fifth Avenue.[12]

In 1921, long before Adams had come under the charismatic influence of Stieglitz, he had tried his own hand at the Autochrome process. It was, to the best of our knowledge, his first experiment with color, which he described in a letter of 1921 to his future wife, Virginia Best (see page 117). In 1921, however, Adams was still more naturalist and pianist than photographer, so his very early experiment with color and his enthusiasm for the medium are all the more remarkable. He was entranced by the luminosity of the Autochrome and the relative ease of making a color image with a single exposure. In fact, Adams never lost this initial attraction to the vibrancy of the transparency, carrying it forward with him throughout his career, referring time and again in his notes on color to his preference for color transparencies over prints.

The Autochrome survived into the early 1930s, but then died a quiet death when it was replaced in 1936 by 35mm Kodachrome and by sheet film Kodachrome in 1938. At about this same time, in 1937, another photographer of great accomplishment, László Moholy-Nagy, was expressing his views on color photography, while Adams was formulating his own thoughts on the matter. There is no evidence that Adams was aware of Moholy-Nagy's paper "Paths to the Unleashed Colour Camera," published in the *Penrose Annual*. Nevertheless, Moholy-Nagy's was an important voice in American photography and art in 1937, when he opened the New Bauhaus school in Chicago. His views, in whatever ambient form they might have reached Adams, most certainly contributed to the general aesthetic attitude of the period.

Moholy-Nagy's essay was both an acknowledgment and a prediction that color photography was about to be "unleashed" from its cumbersome past: "Colour Photography still sets itself the same tasks which the best photographers of the pioneer period were already solving a century ago."[13] He went on to predict that new single-exposure cameras would set the color photographer free by making it possible to make colored snapshots — by which he meant images that incorporate the unusual angles and points of view characteristic of the black-and-white photographs of the original Bauhaus. He also introduced the idea that, in the future, the new medium could be used to produce color photograms and abstractions.

15

He provided an analysis of Cézanne as the basis for color photography, tracing three periods of the painter's work, which naturally culminates in abstraction and color tensions.

This issue of abstraction, evident in the early stages of color photography, would present difficulties for Adams throughout his search for a color aesthetic. Moholy-Nagy's concept could not be further from Adams' own. More than once in his notes Adams referred to his impatience with and dislike for abstract color photographs. His dilemma with color photography becomes apparent: he cannot accept it as a representation of reality and, at the same time, he is very suspicious of abstraction, and in particular, as he says, "I thoroughly dislike 'abstract' color photography that merely apes abstract painting!"[14]

In 1930 Adams reached a turning point in his life; he decided to give up music for a life in photography. He attributed his decision to an experience on a trip to New Mexico in that year. On this fateful trip he saw Paul Strand's negatives held up to the light like transparencies, each one glowing with great luminosity. Years later he became adamant that no color process could produce the quality of light inherent in a color transparency. In his black-and-white photography Adams found a means of creating images that contained a sense of light equal to the dramatic luminosity he admired. But for him that goal remained elusive in color photography.

In numerous lectures and discussions throughout his life he described that quintessential moment when he was transfixed by the great beauty of Strand's negatives. Adams suddenly felt the raw fundamental potential of a personal vision in photography. But it was the consummation of an already prepared mind. Adams had met Edward Weston two years earlier, in 1928, and had made *Monolith, The Face of Half Dome* in 1927, a work which embodied the same drama and formal elegance that Adams recognized in Strand's negatives. Its visual sophistication and control mark the earliest point of a mature vision in Adams' work.

In 1933 Adams met Alfred Stieglitz on a trip to New York City, and the final verification of his own vision began. From Weston, Adams learned of "pre-visualization" and the value of seeing a subject in the mind's eye as a photograph in its entirety before exposure. Adams refined this concept into what he called *visualization*. From Stieglitz he gained an understanding of a photograph as an *equivalent* — an image that could evoke equivalents to the experiences, thoughts, emotions, sensations, felt by the photographer at the time an image was made. By the end of the decade he had developed his famous zone system — a practical interpretation of sensitometry that allowed him visually to divide an image into a range of nine

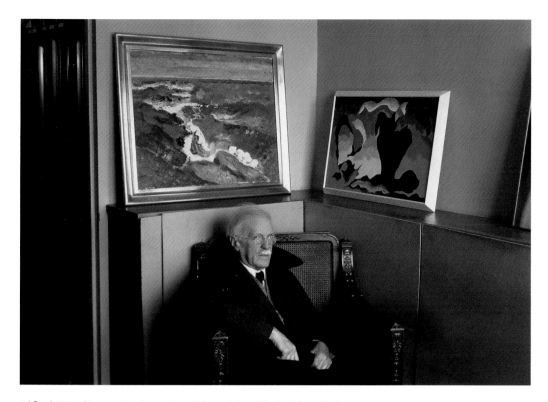

Alfred Stieglitz at An American Place, New York, New York, c. 1945

different zones from black to white; the purpose was to optimize exposure and development control of the negative or transparency in terms of desired results or visualization.

This triad of visualization, equivalents, and the zone system provided the basic aesthetic tools that Adams applied to his photography throughout his life. By the mid-1940s, when he began to experiment with color photography in a concentrated manner, he insisted that color image-making be subject to these controls in order to meet the minimum standards of what he would call a satisfying work of art. Technical control of the color medium was difficult, if not impossible, to attain in the medium's early years. This was another reason that Adams chose to keep most of his color work in an experimental stage:

Color photography is a beguiling siren for the dilettante, but a scourge for the professional and serious photographer. So much is done superficially, so many millions of images are seen, that it is difficult, even for the serious worker, to realize how important are constant observation and visualization, in terms of rigorous practice and experiment.[15]

For forty years, beginning in 1930, Adams was able to balance his energy and time between commercial photography and his own work. His livelihood came from select commercial assignments, which he never confused with his work as an artist.

The professional photographer takes assignments from "without," injects what imagination he can apply, and does the best he can with the problems presented. The creative photographer, on the other hand, takes assignments from "within" and, if truly dedicated, may find that the client is tough and uncompromising! The conflict of the assignments from "without" versus those from "within" often perplexes the serious photographer.[16]

During the forties and fifties in particular Adams made the majority of his commercial color works. Only major magazine publishers during this period could afford the high cost of materials for the process and provided the only practical venue for color images. This industry was also not concerned, at least in most quarters, with whether or not the then extant processes transgressed any philosophical questions of reality, integrity, or photographic ideals, or met tests of color accuracy. The publishers recognized the public's attachment to *living color* and were eager to fulfill their desires by selling more publications. The dilemma for artists like Adams in exploring color was intensified by its commercialization, which was the only other taboo for the serious photographer of the early and mid-twentieth century.

In regard to his color commercial work Adams credits Anton Bruehl as teaching him the most about color, especially for studio work. In his autobiography he describes Bruehl as "a superb craftsman and a pioneering artist in the production of the finest professional color work of the 1930s found in *Vanity Fair* and other publications."[17]

Adams himself produced color commercial works for various publications, including *Horizon*, *Fortune*, and *Life*. In these magazines he produced works for corporations such as Kennecott Copper, Anaconda Mines, and The Eastman Kodak Company. In his notes for the unpublished color book, he wrote thus about these assignments:

Ever since the appearance of sheet film Kodachrome I have made a large number of color photographs (for professional purposes). The series of begonias for Life *was the most (but only a few were used because of pressing world events, etc.). I did, I estimate, about 12–16 Coloramas for Kodak (Grand Central Station). And, of course, scores, if not hundreds, of landscapes. Out of all of this work I made only a few that pleased me aesthetically, although my basic technique was, perhaps, more than competent.*[18]

He described his work for the Coloramas (giant transparencies, 18 x 60 feet, installed at one end of the concourse of Grand Central Station in New York City beginning in 1948) as "aesthetically inconsequential but technically remarkable."[19] In contrast he described his begonias for *Life* (see page 23) with great approval: "If I say it myself, the results were beautiful, Life was pleased, and I was expectant" (*Life*, September 18, 1950). Apparently the begonias were salvaged as aesthetically satisfying because they

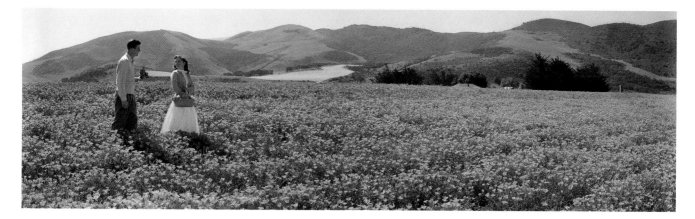

Kodak Colorama of two figures in a poppy field, near Lompoc, California, 1951
(reprinted courtesy of Eastman Kodak Company)

were studio productions under his own control. As with most artists, Adams basically resented the intrusion of any motive other than his own.

Adams was critical of his own accomplishments in commercial color and hard on his peers (with the exception of Bruehl):

The apex of color photography was reached with Anton Bruehl.... Other studios had advanced equipment but lacked the "eye" and taste so essential to fine quality work. It was a remarkable adventure to make photographs of the world in color and the first requisite was to get "realistic" images. As it was impossible to get a truly "realistic image" a concept of pseudo-reality developed in both professional and amateur work and color photographers seemed to revel in smashing, garish color. "If you can't make it good, make it red," was more than a casual remark. As the quality of equipment and materials advance the creative level does not.[20]

Yet in all of his notes and writing on color photography, he reserved an optimistic note for the future potential of the medium itself. He was heard more than once before his death to say that if he were young again and had another sixty years to produce work he would be a color photographer.

There were other photographers of great accomplishment in black-and-white who also experimented with color in the fifties: among them Irving Penn, André Kertész, Walker Evans, Charles Sheeler, Paul Strand, and Cecil Beaton. In 1951 Alexander Liberman, art director for Condé Nast Publications, produced a book on color photography reproducing work by commercial photographers who he deemed stood at the "threshold of the color era."[21] All of the photographs included in the book were either explicit commercial works or still-life arrangements. Each of the photographs was accompanied by a statement about the fledgling medium by the respective photographers. Irving Penn, for example, said

that the color photographer's skill "must be used to keep the fantasy of perfection always fresh and desirable, to open his lens on the world for all to see and marvel at."[22] His statement was a mirror image to Adams' constant reminder that color photography was not and could not be realistic, that it was a departure from reality when it was successful and a distortion when it failed.

Kertész, on the other hand, like Adams, praised black-and-white photography, had serious reservations about color, and proffered its future. Kertész believed that color photography was overtly influenced by thousands of years of painting history in which the aesthetics of color was that of painters' pigments and chosen subjects; that color photography had yet (1951) to find its own exact expression: "…Black-and-white photography, on the other hand, is pure photography. It is a well developed medium that stands by itself, different from painting, but just as pure. When the development of color photography reaches that point, we shall have come the whole way."[23]

In 1947 Eastman Kodak Company invited a number of creative photographers to experiment with the then new 8 x 10 sheet film Kodachrome. The photographers included Edward Weston, Ansel Adams, Charles Sheeler, Paul Strand, and Walker Evans. Evans, who worked for *Fortune* magazine in the fifties, reproduced a portfolio of color works by these photographers in the July 1954 issue (page 77). There he said of the color medium that it was still in its infancy and of the work reproduced that it reflected "the true fresh beauties (as well as the fulsome inanities) of the age." He specifically referred to Adams' image of a rising moon in the Sierra as a "roundly romantic landscape." But at the same time he sounded like Adams when he wrote: "Many photographers are apt to confuse color with noise and to congratulate themselves when they have almost blown you down with screeching hues alone — a bebop of electric blues, furious reds, and poison greens."

Adams himself wrote in the 1978 edition of *Polaroid Land Photography* that the most difficult subject for color photography was landscape. He said the photographer could either wait for appropriate lighting and environmental conditions to match the film or work with close-up subjects in nature. He believed that the urban scene was far more fruitful in its variety and potential for color photography than the natural scene.[24]

A few of Adams' color commercial works are reproduced here (see pages 19, 23) as examples of the kind and style that he produced to satisfy his clients. As mentioned earlier, he kept his commercial and personal work separate and, although the commercial works hold a certain charm for the viewer today, it would be incorrect to imply that they were equal to the work he acknowledged as artistically satisfactory. Ironically, his comment about urban versus natural subjects for the color camera did not

guide his own efforts. The far greater majority of the transparencies he retained in his archive as personal works were landscapes and subjects in nature.

In his autobiography Adams devoted a chapter to his commercial work relating many of the stories that accompanied specific assignments. One such story (from 1958) relates how his efforts to make a Colorama image in Monument Valley ended instead in his taking the now famous black-and-white photographs of aspens in northern New Mexico. Adams described how the desired Colorama scene of dramatic clouds and landscape in Utah never materialized, so he scrapped that project and traveled on to Santa Fe. When he arrived in the hills outside Santa Fe, one of the great sanctuaries for artists, he came across a grove of aspens and found fellow photographers Eliot Porter and Laura Gilpin working in the same area. Adams exchanged greetings and then set about his own exploration of the wondrous landscape and produced two inspiring black-and-white versions of shimmering aspens; these two photographs glow with the radiant light, which has come to represent the visual signature of an Adams work.

More than a decade earlier Adams had made another image of aspens — in color (page 43). Between 1941 and 1947 Eastman Kodak Company gave him and other photographers 8 x 10-inch Koda-chrome sheet film for experimentation. In 1947 he made a stately, if reserved, color photograph of a grove of aspens on the North Rim of the Grand Canyon. The photograph is subtle and shows none of the drama of his mature, later style. Yet this early color photograph of aspens and a black-and-white compan-ion print that he made at the same time may be seen as the precursors to the more sophisticated treat-ment he gave to the same subject eleven years later.

What Adams may have learned from his color trial with the aspen grove in 1947 was a way of "visualizing color" as opposed to monochrome. Before Adams could comment on "seeing in color" he had first to learn the lesson himself. He made a point of the importance of learning from every venture. Hence, his experiences with his color experiments were no doubt as meaningful to his black-and-white work as was his commercial work to his personal creative efforts.

By 1970 Adams was able to leave commercial work and turn exclusively to his personal photogra-phy. While he used color successfully as a process in his commercial work, his real interest in color was as a new tool for creative expression. He wrote extensive notes, published several articles on color, and as mentioned earlier had made several outlines for a book on color. He insisted that this book would not be a technical volume since he did not believe he had a full grasp of the technique, even by 1983, the date of the last of his draft outlines. The book would instead be about "practical color aesthetics and the control of color values.... Visualization is of prime importance."[25]

Adams' writing on color in note and draft form may have been extensive, but it was not cohesive. It spreads over several decades and vacillates between periods of optimism and pessimism about the potential of color photography as a creative medium. As he struggled to master color for his own use, he sensed that it was on the verge of becoming not only technically accessible, but accepted and used universally by artists for the first time in history. Had he lived but another five years he would have seen a dramatic shift in the history of photography as it embraced the creations of a new generation of color photographic artists.

Despite his misgivings about his own creative color work, he could appreciate the efforts of others, and many of the artists whom he believed in as successful color photographers, even during his years of doubt, are now acknowledged masters of the medium.

In 1961 Marie Cosindas enrolled in Adams' Yosemite workshop where one of his prime efforts was to impart his concept of "visualization." In his notes for the color book he recalled an incident with Cosindas:

It is most important to realize that the "composition" (visualization) of the color image is distinctly different from that of the black-and-white. Some of us instinctively "see" better in color. A good case in point is the experience the eminent color photographer, Marie Cosindas, had at one of my early Yosemite workshops. Marie was devotedly working with her 4x5 view camera and black-and-white film. On several occasions she would ask me to check an image on her groundglass. In each case she had a beautiful photograph but the values were soft and subtle and—as they would be rendered in quite similar values in the black-and-white print—the result would be drab and monotonous although the arrangements of shapes was sensitive and pleasing. I would say to her "Marie, you are handling shapes in the format very well indeed but you are 'seeing' in color; your composition will not be realized in black-and-white."[26]

Adams was right in his admonition to Cosindas in terms of how she was instinctively seeing the subjects on her groundglass. She has made some exquisite black-and-white photographs, but her real aesthetic forte was and is today color photography. The Polaroid color medium is to Cosindas what monochrome silver prints were to Adams. Cosindas was one of the few photographers Adams felt was truly expressive in color.

The fact that Cosindas worked almost exclusively in Polacolor from 1962 on must have had an impact on Adams' own investigation of the Polaroid instant color process. Adams was a technical consultant to Polaroid for many years (1949–1984), testing and using black-and-white materials, as well as color, for the research division. Some of his well-known black-and-white images, such as *El Capitan, Yosemite, 1968* (*Singular Images*), were produced with Polaroid negatives. But even though he was able to

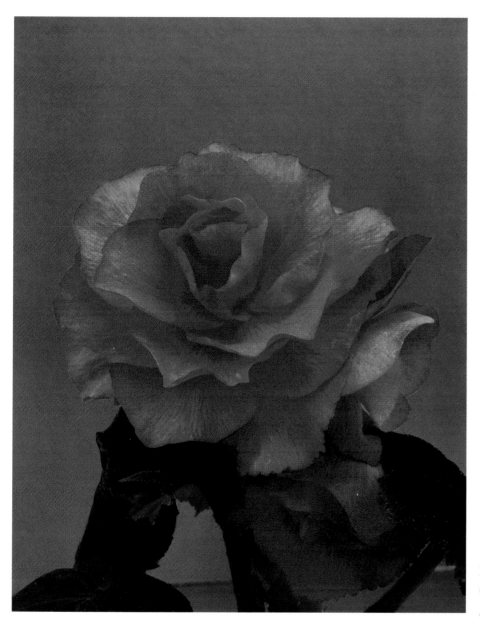

Begonia, Santa Cruz, California, 1950 (published in *Life*, September 18, 1950)

appreciate the achievements of others with instant color, he produced no significant instant color works for himself because he could not accept the lack of dependable controls, as he described the inherent trial and error process of the instant medium. However, the experimental nature of the process always appealed to him and inspired his appreciation.

Unquestionably, the most prominent photographer of Adams' generation to use color for purely creative purposes was Eliot Porter, and Porter's work presented great difficulty for Adams. In 1962 he referred to a new book of Porter's published by the Sierra Club as "an astonishing job and a work of

great emotional impact."[27] Even so, he believed that many of the reproductions of Porter's he saw had too much "fortissimo," and even though Porter explained that the strong colors existed in nature, Adams could not accept them as photographs; strong color was for him analogous to excessive contrast in a black-and-white print.

When Adams was asked by *Artforum* publisher John Irwin in the same year to write a review of Porter's book (*In Wildness is the Preservation of the World*), he declined. On the one hand he admired Porter's achievement, but on the other he still had feelings of distrust and dislike for color photography. He said of Porter that what he saw, felt, and "how he trimmed his creative sails to the sharp winds of Thoreau" were self-evident; that for him to add comment or review would be a kind of "lily-painting" and that he fundamentally didn't like color photography — one of his more pessimistic public stances.[28]

On the issue of accepting color photography Adams adjusted his thinking numerous times. For example, a few years earlier in 1957 he wrote of yet another color photographer whose work he admired: "Ernst Haas opens new vistas of perception and execution with the color camera. His 'recognition' becomes our experience!"[29] Later on in the same article he also commented that he had yet to see a color photograph that met his expectation of a work of art or "that happy blend of perception and realization which we observe in the greatest black-and-white photographs."

As mentioned earlier, Ansel Adams struggled with the three fundamental issues of reality, control, and aesthetics, but none was more troublesome to him than control of the process itself. He would not accept a way of working that could not provide consistent and predictable (visualized) results.

In his writing on color there exists an undated essay, somewhat more finished than others, entitled "Color and Control," which summarizes his difficulty with the medium.[30]

The style of the prose and its largely skeptical attitude suggest that the essay was written early, perhaps in the 1950s. The essay pits color against black-and-white photography in terms of technical control as the essential ingredient for creative expression. Adams identifies that difference as follows:

Art implies control *of reality, for reality itself possesses no sense of the esthetic. Photography becomes an art when certain controls are applied: camera position, focal length of lens, filters, negative material, exposure, development and printing procedures. In black-and-white photography, it is possible to create within the medium....*

There is great confusion today — not only in the minds of the public but also in the minds of many photographers — as to what the basic qualities of color photography really are. Most successful color, in the movies or

stills, comes from outside the camera or the medium itself. *It comes from the organization of what is to be photographed, from controlling the hue and light of everything that will be perceived within the picture area. The color is in the subject....*

Personally, I am a realist when I approach color photography. I accept it as a realist expression, and am distressed when the color is "off." I have produced, in relation to my work in black-and-white, comparatively little color, and most of what I have done is concerned with rather spectacular aspects of the natural scene.

Adams believed that control of one's medium was essential to producing the required visual information from which to derive a simulation of reality: he noted that works of art are more about illusion than realism. An expressive print, he believed, must be visualized and then produced to evoke the feelings and emotions he experienced with a given subject. He attempted to provide an example of the difficulty of such an effort in color photography with the following story:

Walking about the Yosemite Valley I strolled across a bridge over the Merced River and considered the scene before me. Half Dome dominated the scene with a brilliant thunderhead looming over it. The sunlit pines were a rich, cool green, and the oaks and willows were brighter and yellower. The deep shaded pools of the river were of dark, complex green. The forest shadows were darker. A man was fishing stream-side, with black waders and a cool orange jacket which literally blazed in sunlight against the dark forest. I looked from area to area of the scene; each revealed color and luminosity and could be painted in unlimited interpretations of form, color and texture.

Moved by the scene, I tried to visualize a color photograph. The problem was formidable and I am sorry to say, unmanageable....

I am frustrated by both exposure-scale limitations and rigid film-color response. As "reality" is out of the question, I can indulge myself with explorations of the "unreal" color which may or may not have intriguing aesthetic effects. I would not want "post-card" realism, but I would enjoy "enhancements" of the colors which I fear is not possible with conventional material today.... The scope of control with the electronic image has not been explored, but I feel confident astonishing developments await us in this area.[31]

Written in 1983, his comment about electronic photography (digital imaging) was prophetic. Today, a decade later, electronic imagery and color are inseparable; they are one and the same and commonplace. Manipulation of digital color images is the norm. With such infinite controls as are offered by electronic imaging, Adams would have finally found the answer to the medium's technical limitations. He would, however, still have had a problem with the finish of the work. If dyes were not tactile and pigment-like enough for him, then he would have had even greater difficulty with today's color thermal, laser, and jet-graph prints common to the electronic medium.

Adams continued to experiment late into his life with color printing processes, looking for one that would convey the luminosity of his original transparencies. Correspondence with a custom printer from Los Angeles, Wally McGalliard, during the last year of Adams' life reveals that dye-transfer offered the most positive results of any process.

As early as 1970 McGalliard had written to Adams asking for the opportunity to make a dye-transfer print from one of his early Kodachromes. Adams did not reply for several months until Beaumont Newhall urged him to do so.

Newhall had left the George Eastman House in 1971 to become a professor at the University of New Mexico and in the process of preparing to move discovered one of Adams' Kodachromes in his possession (a rear view of Ranchos de Taos Church, New Mexico). He sent it to McGalliard and asked him to make a set of separation negatives for preservation's sake and a print. He informed Adams of his action and encouraged him to renew contact with McGalliard, whom Adams had known before.

Adams wrote McGalliard immediately (July 1971), inviting him to participate in a planned workshop in Yosemite on creative color with Marie Cosindas and Al Weber and promised to select a transparency for a possible print. The Ranchos de Taos print was completed, but whether there were other satisfying prints made from other transparencies is not clear from the correspondence record. They remained in touch and then in 1980 Adams commissioned McGalliard to print from transparencies he made of President and Mrs. Carter the year before. Finally in 1982 a selection of eight additional transparencies was printed by McGalliard, which Adams called "remarkable." But in spite of the compliments and McGalliard's valiant effort to resurrect the aging color of the transparencies, Adams maintained the same reserved tone about his color work throughout their correspondence.[32]

We know from his notes that Adams was less biased against printing-press reproductions and allowed a few images to be published during his lifetime. He had developed, over the scope of his career, a knowledge and feeling for quality printing-press reproductions for black-and-white, as well as color. He sought out the best printers and challenged their best efforts with his "aesthetic" knowledge of their medium. In a note to one of his assistants he wrote:

I also did a lot of work with printing-press reproductions of color pictures. While, in no way, could I claim technical knowledge of the actual processes involved I nevertheless know much about the nature of color-separation, negative and plate manipulations and printing inks. Press reproductions have always had a greater potential for "quality" than have actual photographic color prints.[33]

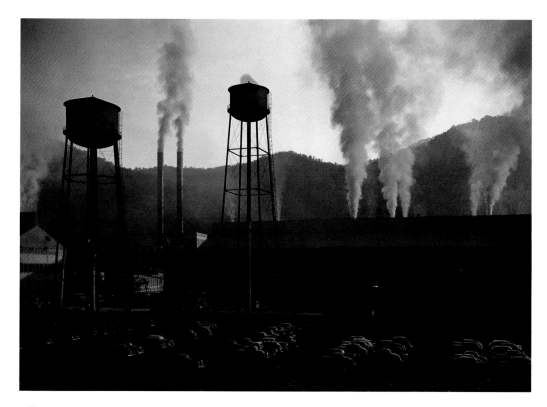

Alloy, West Virginia, c. 1939

Control of color technology was a singularly important problem for Adams and it stood apart from all other concerns. But reality and aesthetics were inseparable from each other as issues of artistic concern for the integrity of the medium.

Adams described himself as a realist in color photography, even though he generally denied that photography was about realism. He expressed it in the following way:

The difference between black-and-white and color images is not as obvious as we may assume without due consideration of the process of "seeing" and interpreting what we "see." A photograph is a simulation of a perception of the world around us — rather, of a fragment of this world selected from the universal chaos. The image — to the photographer — is a very different experience from what the viewer might receive from it. In conventional photography the optical image given by the lens has realistic delineations of shape and texture. This gives us confidence as to the subject and the "realism" of the photograph. Once we have this parameter of the image, we naturally seek other parameters of color and value which further confirm our impression of "reality."[34]

Whenever Adams uses the word "reality" in his writing he places it within quotation marks. This represents his own philosophical statement about the nature and existence of a photographic reality,

which differs significantly from physical reality. It is, in his view, the responsibility of the artist to enhance optical reality by way of photographic controls (visualization, zone system, printing procedures) in order to provide an impression that is more communicative than reality itself. He understood in relation to his black-and-white photographs, as stated in a variety of publications, that his work was not about realism, but the impression or equivalent of an experience in reality. A black-and-white photograph, he said, was an almost complete abstraction and could exist in a world of fantasy and stylization, simply because it was not dependent upon the blatant reality of color. Color on the other hand caused great confusion about realism.

In regard to the relationship between aesthetics and reality he made the strongest statement of all at the peak of his investigations with color in 1962. He wrote:

There is little or no "reality" in the blacks, grays and whites of either the informational or expressive black-and-white image, and yet we have learned to interpret these values as meaningful and "real."

With color photography we are introduced to a more potent "trap of reality," and this fact is accentuated when we can make an immediate comparison of the color print with the subject. With conventional color photography, there is always a delay between the making of the exposure and seeing the final product (transparency or print). Comparisons are made with memory rather than with fact! If the colors do not distress us by obvious falseness or poor aesthetic relationships, we accept the conventional color picture as a statement, a symbol, or even as a record *of the subject. In my experience, no color photograph will convey a truly* accurate *interpretation of the subject although one color may be more satisfactory than the others.*[35]

He finally resolved in his own mind that color photography could offer potential aesthetic experiences, if it could be seen as a means of simulating reality, rather than recording it.

He came to believe that great aesthetic works, those that exceeded the documentary nature of reality, were possible in color, but that they were due either to the special color sensitivity of unique individuals like Cosindas, Porter, and others, or to the careful selection and "seeing" of subjects. He placed himself in the latter category and fought to find a way for other photographers and the audience to unlock the nature of a color aesthetic that could control subject matter, rather than being controlled by it.

Intuitively, Adams felt and vociferously advocated that understatement was preferable to exaggeration in color. He defined the potential aesthetic print as one that had the right "feel" or "rightness" of colors, and the saturation of dyes, pigments, and general color key had to be in harmony with the emotional feelings of the subject. He found most color photographic papers wanting in texture and quality. He, therefore, preferred the luminescence and color saturation of projected transparencies.

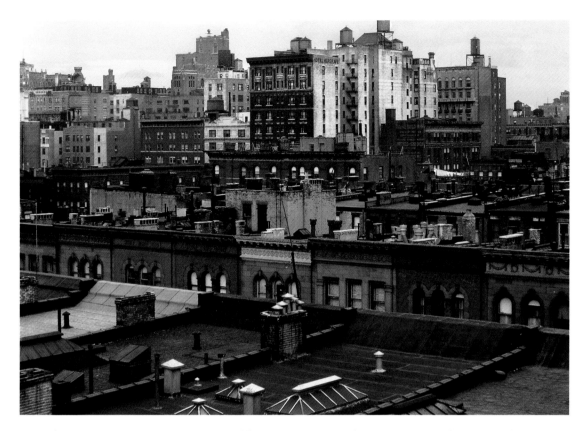

View from Beaumont and Nancy Newhall's apartment on 56th Street, New York, New York, c. 1942

Adams believed that he created the equal to color in his black-and-white photographs. He saw the infinite variety of gradations of tone as variations in color. While he wrote about this concept in his notes, he also set the idea aside as too subtle for most people. He also believed that the eye-mind-psyche complex can perceive extremely small differences of value and color and, based on this ability, a person instantaneously accepts or rejects creative images. This was certainly true for Adams himself, if not for the average person.

Adams was not unaware that there was considerable work being done in color photography during the 1980s that was accepted by the photography art world. He in fact updated his list of accomplished color photographers to include Joel Meyerowitz and Olivia Parker.

He recognized that there was much happening around him championed by a new generation of color photographers. Even if he was unable to appreciate most of their work, critical analysis of his comments would show that it was more their concept of aesthetics and choice of subjects that he distanced himself from and not their use of color. By 1981 he was seventy-nine years old and as is true

of most artists in the autumn of their careers, he left the changing of the guard to the avant-garde. He worked from a different set of aesthetic standards and saw beauty and visual pleasure as paramount. Even so, he had become sufficiently sophisticated in his understanding of color to write:

I believe we should encourage non-real explorations into worlds of color hitherto restricted to painting. Only the technical rigidities and the fear of the unreal have held interpretive color photography to rather narrow paths. It now appears that the horizons are opening for new creative-emotional concepts that can be achieved in the domain of color imagery in the photographic mode.[36]

The final step in his quest to bring color photography within creative control for himself and others was to write his planned book on theory and practice mentioned earlier. For nearly a decade (c. 1976–1984) he worked on just what he would say and what works would be reproduced in "book 5" of his technical series. He insisted that the book would be more about aesthetics, and less a technical manual. The practical chapters were to be written by guest authors. He planned to reproduce a few of his own color transparencies, a selection of paintings, and predominately contemporary photography to illustrate sections on color theory, technology, reproduction processes, and aesthetics.

A "final" outline written in 1982 was followed seven months later by a letter in which he evidenced total confidence and enthusiasm for the color book:

I have reached a stimulating level in regard to the Color Book. I feel encouraged! All the thoughts of the past several years have come to focus. I think it will be a unique work — one of my best — and a real contribution.[37]

Adams died one year later, in 1984, without the opportunity for what would have been partial resolution of his most ardent struggle with color photography.

This book of Adams' color photographs appears a decade after his death. It was the crucial decade of the 1980s that liberated photography from its ancestral prejudice against color photography as an art form, while ironically having sanctioned its commercial exploitation for nearly half a century. Had Adams lived, the photographs reproduced here might have been seen in a new light of recognition and accepted by him as appropriate for further attempts in producing prints. As has been shown, throughout his career he commented that his transparencies, which serve as the source for these images, were significant achievements, but that he had not found a way to produce them as prints to his satisfaction. Because he could not accept the imperfection of the then extant printing processes, he chose instead simply to save the transparencies the way a painter might save a drawing that for one reason or another never evolved to any other form of expression.

One can imagine that if Adams had been given the opportunity to submit his color transparencies to computer manipulation or other color control processes of today, these "color sketches" would have had lives as different from their first stage as do his black-and-white prints from their negatives. We could rightfully expect that each final product would have had a presence and elegance comparable to the emotional "tuning and phrasing" he gave his monochrome prints and before that his musical achievements. We do know from his writing that he accomplished in the camera what he desired, images as equivalents to his experiences. What we cannot project is what he would have done to enhance the order and structure of the color itself in order to change the recorded impression of nature into what he called *expressive images*.

The inherent limitation of knowing that Adams regarded the images in this book only as sketches should in no way inhibit our ability to appreciate them. On the contrary, some would say that the first impression, that initial spontaneous moment when an idea is first captured by an artist, is the most pure, undiluted aesthetic nectar that an artist has to offer. Those viewers willing to let visual pleasure be the primary catalyst to their emotions and appreciation of works of art will find in Ansel Adams' color photographs the affirmation of a great naturalist's life as told from his sketchbook.

NOTES

1. Ansel Adams, note on color photography (March 22, 1983), Ansel Adams Estate: "When electronic imagery becomes a manageable medium the aesthetic principles of color will be retained, but the technical procedures will vastly change."

2. Adams, notes (September 8, 1978), Adams Estate.

3. Adams, letter to Michael Wilder (September 30, 1983), Adams Estate.

4. The author has been present at several of Callahan's lectures when he has attributed to Ansel Adams the inspiration he needed for devoting his life to photography. Callahan recalls attending a lecture and workshop in August–September 1941, sponsored by the Photographic Guild of Detroit, that featured Adams. See also Keith F. Davis, *Harry Callahan Photographs from the Hallmark Photographic Collection* (Kansas City: Hallmark Cards, 1981), p. 51.

5. Interview with the author, April 1, 1992, at the International Museum of Photography, George Eastman House.

6. Adams, notes (March 22, 1983), Adams Estate.

7. Brian Coe, *Colour Photography: The First Hundred Years 1840–1940* (London: Ash & Grant, 1978), p. 8.

8. J. H. Croucher, *Hints on the Daguerreotype — Photographic Pictures* (Philadelphia: A. Hart, Late Carey and Hart, 1853), p. 199.

9. Adams, notes, "Introduction to color book" (March 22, 1983), Adams Estate. This introduction went through many drafts and was never completed. Most of the drafts are brief outlines for different potential versions of an introduction.

10. Georges Potonniée wrote in his essay "Louis Ducos du Hauron: His Life and Work" (in *Early Color Photography*, Introduction by Sylvain Roumette, New York: Pantheon Books, 1986) that Ducos du Hauron failed in his published account of the process to give sufficient details of his method of operation and by involving himself in a "maze of obscurities" allowed his detractors

to discredit the invention. "Upon the whole the matter hardly reached anyone beyond a limited circle of specialists," wrote Potonniée. There is also an intriguing account of Ducos du Hauron's sending Blanquart-Evrard (a French photographer and inventor from Lille who introduced the mass production of printing photographs by inventing albumen paper in 1850) a set of three-color negatives of a flower subject. Apparently Blanquart-Evrard "had intended since 1870 to establish a color printing plant," but unfortunately died in 1872. As of 1914, the date of Potonniée's paper, the Société Française de Photographie had a color proof of the flower subject and a pamphlet about the print dated 1872.

11. Coe, *Colour Photography*, p. 42.

12. *Early Color Photography*, n.p.

13. László Moholy-Nagy, "Paths to the Unleashed Colour Camera," *Penrose Annual*, vol. 39 (1937), p. 25.

14. "Ansel Adams on Color," *Popular Photography* (July 1967), p. 82.

15. Adams, notes (April 13, 1983), Adams Estate.

16. *Ansel Adams: An Autobiography* (Boston: Little, Brown/New York Graphic Society, 1985), p. 162.

17. Ibid.

18. Adams, notes (October 25, 1981), Adams Estate.

19. Adams, *Autobiography*, p. 174.

20. Adams, notes (March 4, 1983), Adams Estate.

21. *The Art and Technique of Color Photography*, ed. Alexander Liberman (New York: Simon and Schuster, 1951), p. x.

22. Ibid., p. 2.

23. Ibid., p. 44.

24. Ansel Adams, *Polaroid Land Photography* (Boston: New York Graphic Society, 1978), p. 59.

25. Adams, note to Bob Baker (December 15, 1982), Adams Estate.

26. Adams, notes, "Trial on Color Photography Introduction" (August 28, 1979), Adams Estate.

27. Adams, letter to "Morse" at Polaroid Corporation (November 7, 1962), Adams Estate.

28. Adams, letter to John Irwin (December 13, 1962), Adams Estate.

29. *Image*, vol. 6, no. 9 (November 1957), p. 217.

30. Adams, essay entitled "Color and Control," with notation "copy to file" (no date), Adams Estate.

31. Adams, notes (April 1, 1983), Adams Estate.

32. This description of Adams' collaboration with McGalliard on printing some of his transparencies at various times between 1970 and 1982 is documented in correspondence provided by the Adams Estate, Carmel, California.

33. Adams, notes, "Trial on Color Photography Introduction" (August 28, 1979).

34. Adams, note entitled "Ideas" (March 2, 1982), Adams Estate.

35. Adams, draft of article on Polacolor (December 8, 1962), Adams Estate, pp. 2–3.

36. Adams, notes (December 19, 1981), Adams Estate.

37. Adams, memorandum to Bill Turnage and Dave Vena (March 28, 1983), Adams Estate.

ANSEL ADAMS IN COLOR

Half Dome and Clouds Rest, from Glacier Point, Yosemite National Park, California, 1949

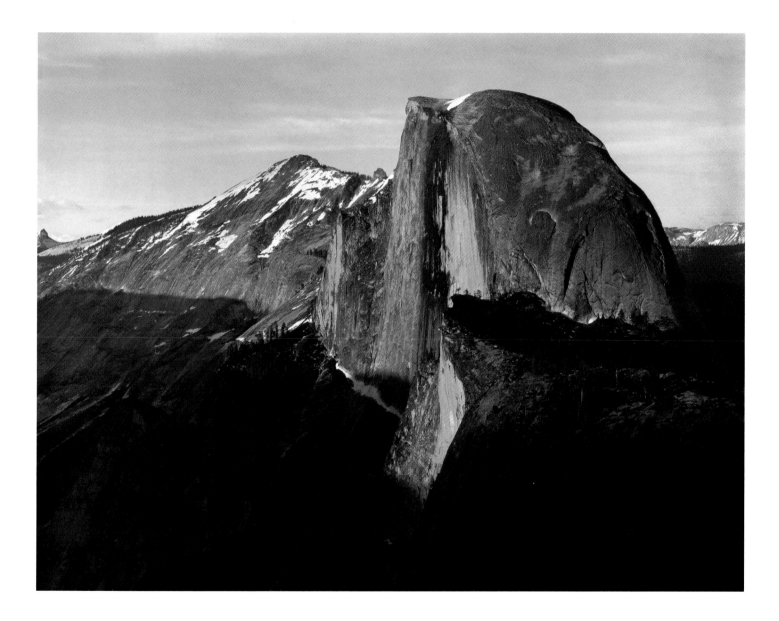

Autumn Forest, Yosemite National Park, California, c. 1946

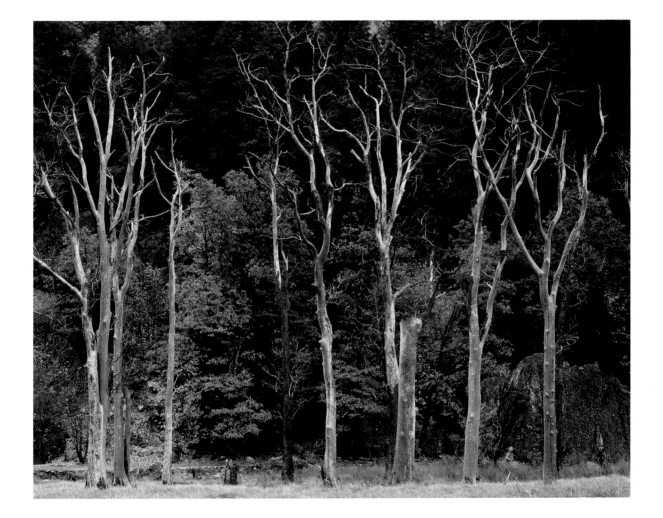

Detail, Pool, Tuolumne Meadows, Yosemite National Park, California, c. 1947

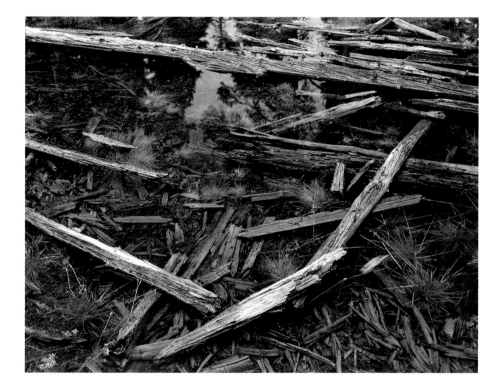

Yosemite Falls, Yosemite National Park, California, c. 1953

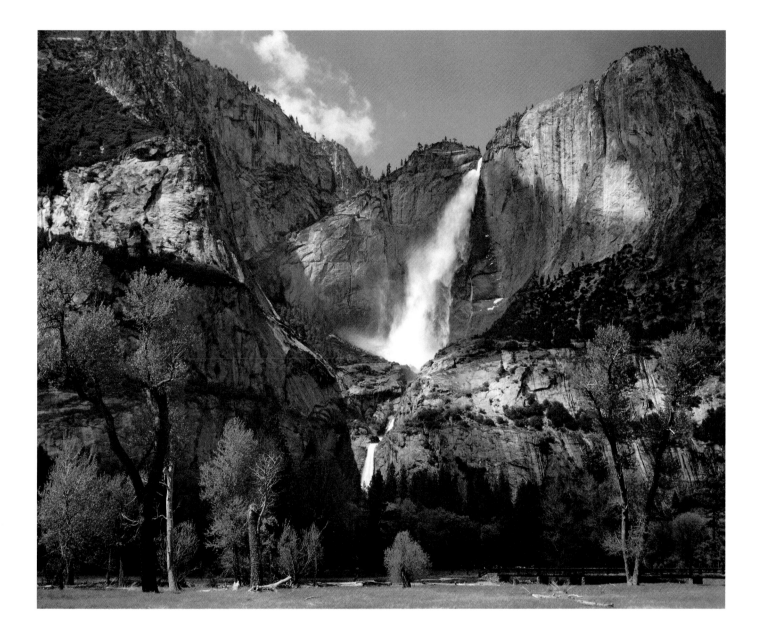

Aspens, North Rim, Grand Canyon National Park, Arizona, 1947

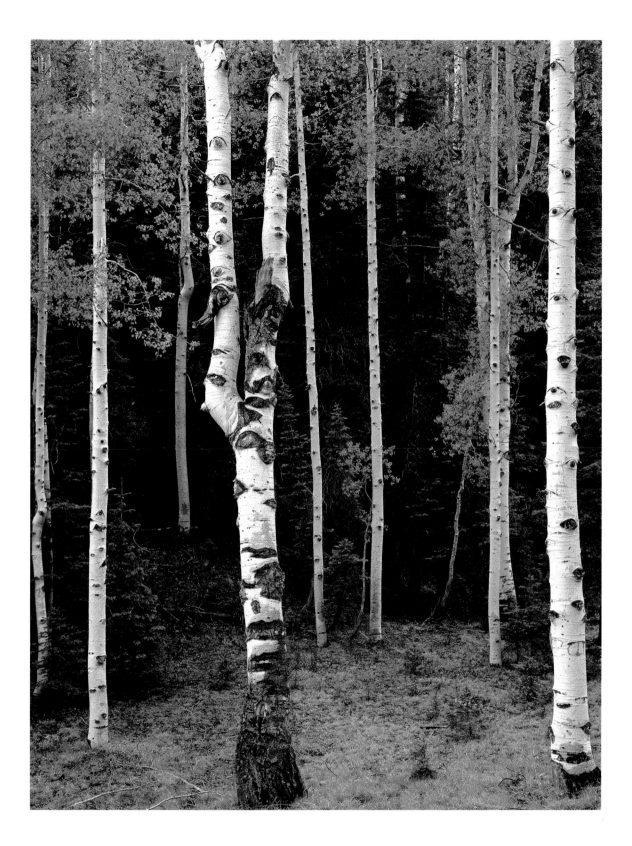

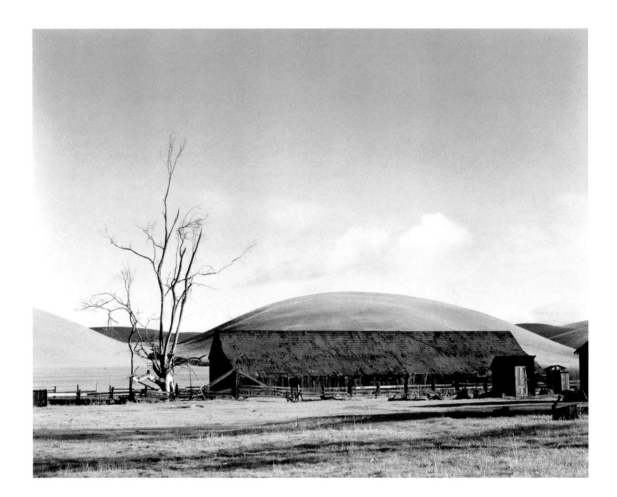

Tree, Barn, Hills, near Livermore, California, c. 1950

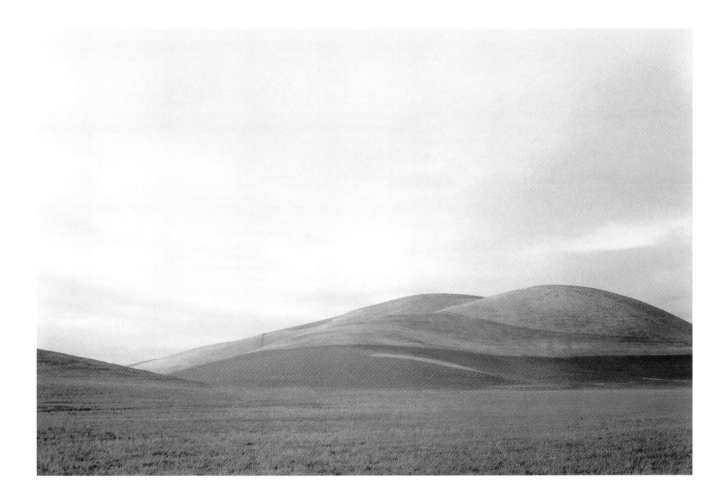

Green Hills, Evening, near Gilroy, California, c. 1945

Mount McKinley, Grass, Denali National Park, Alaska, 1948

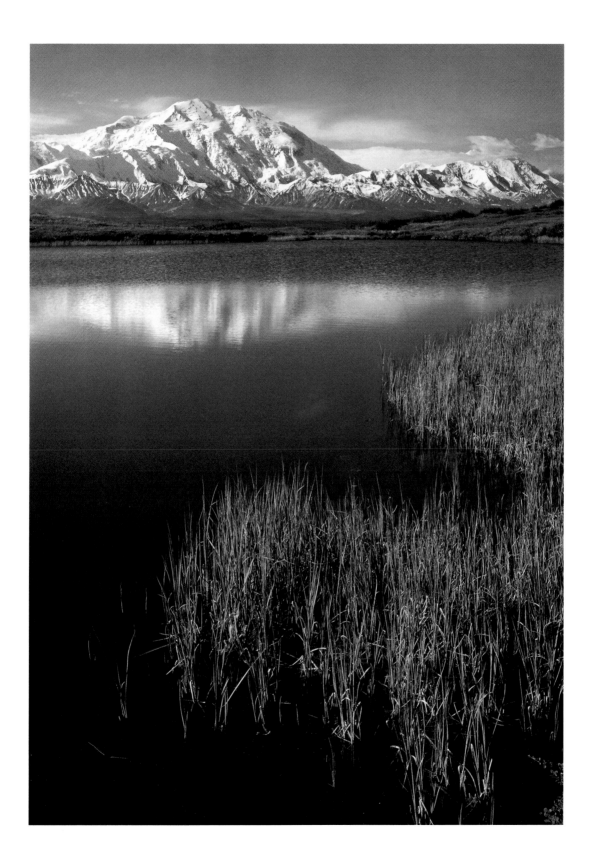

Pool, Kaibab Plateau, Arizona, 1947

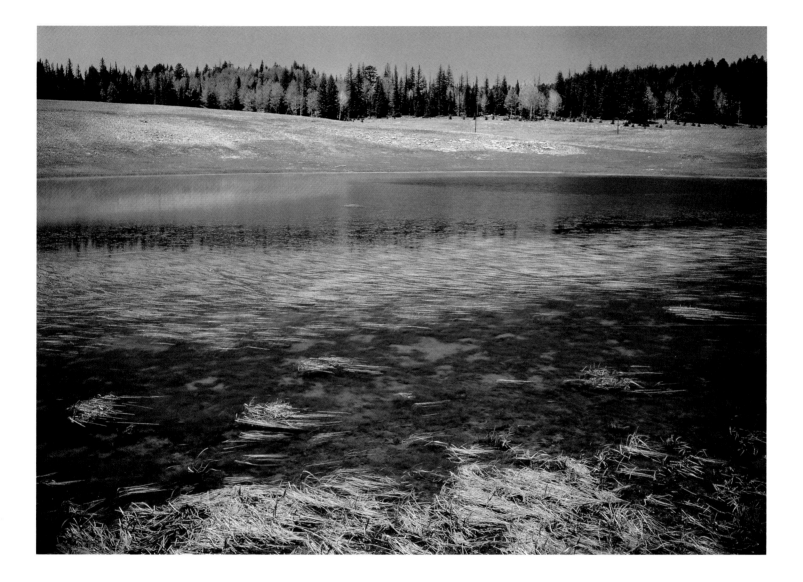

Wainiha Bay, North Shore of the Island of Kauai, Hawaii, 1948

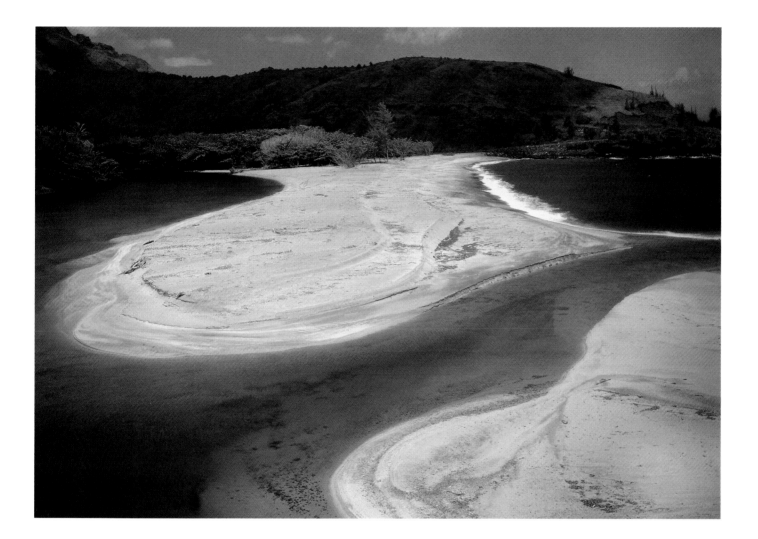

Santa Elena Canyon, Big Bend National Park, Texas, 1947

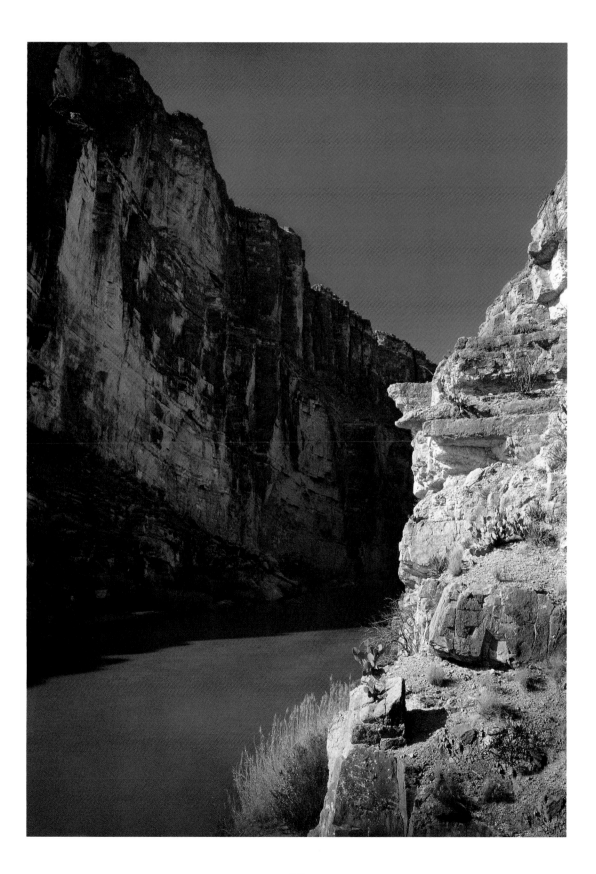

Landscapes, near Philmont, New Mexico, 1961

Pool, Kaibab Plateau, Arizona, 1947

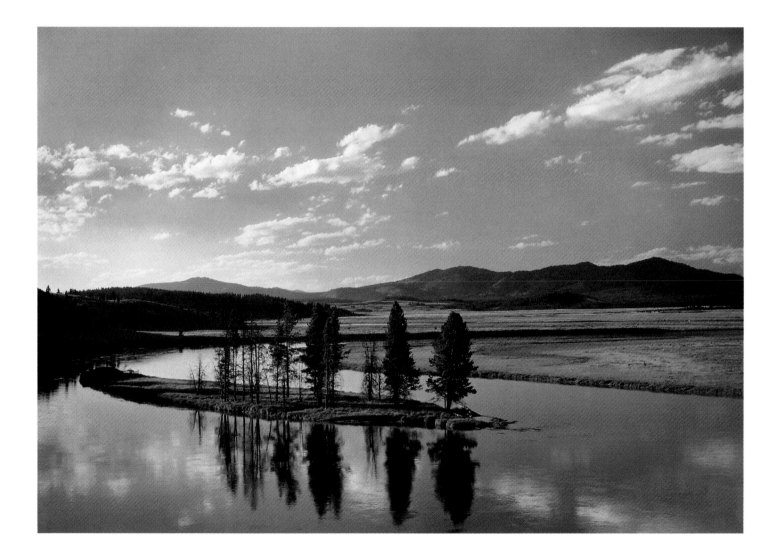

El Capitan, Guadalupe Mountains National Park, Texas, 1947

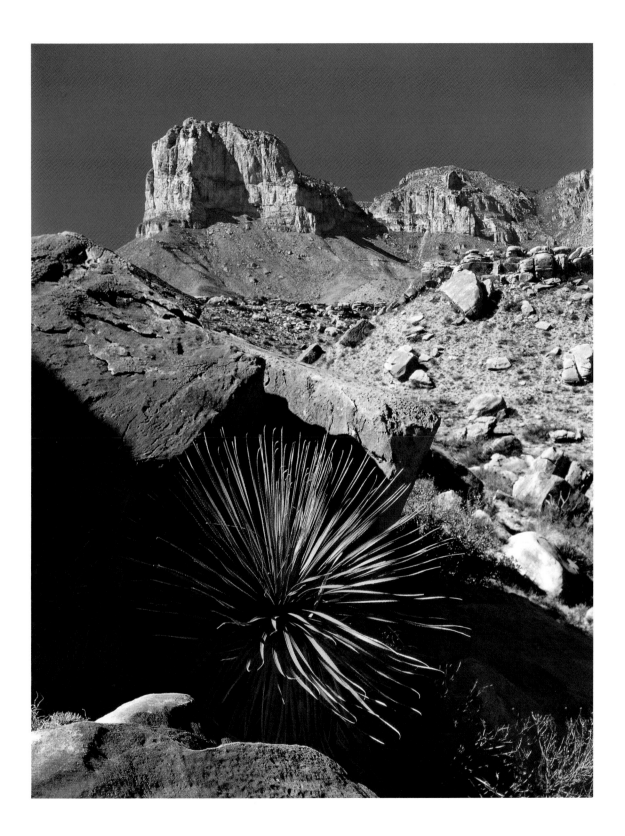

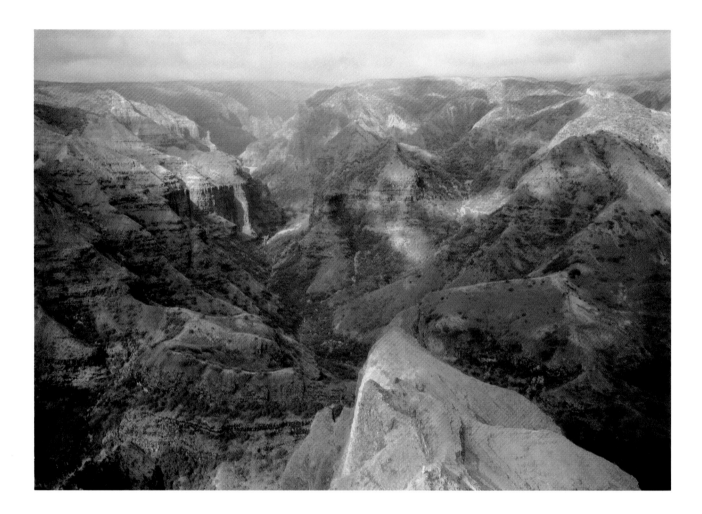

Waimea Canyon, Island of Kauai, Hawaii, 1948

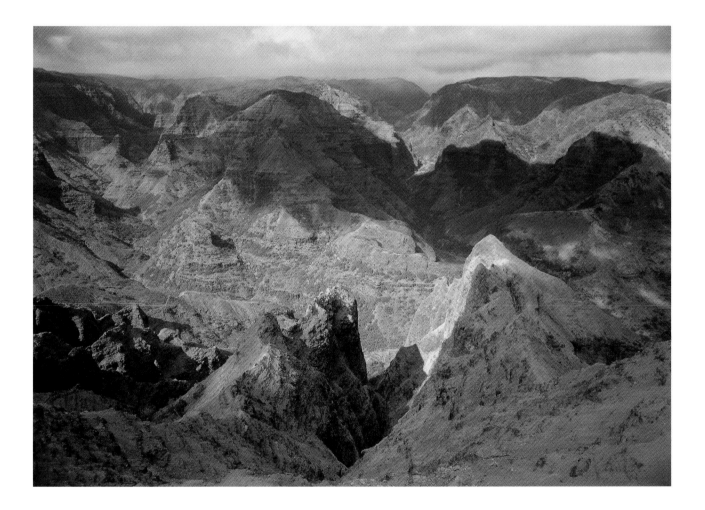

Waimea Canyon, Island of Kauai, Hawaii, 1948

Clearing Storm, Yosemite National Park, California, c. 1950

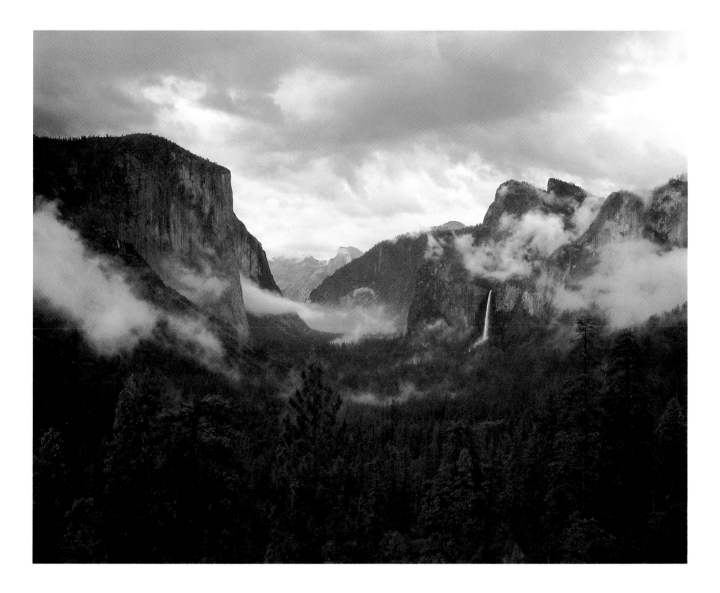

Lower Yosemite Falls, Yosemite National Park, California c. 1946

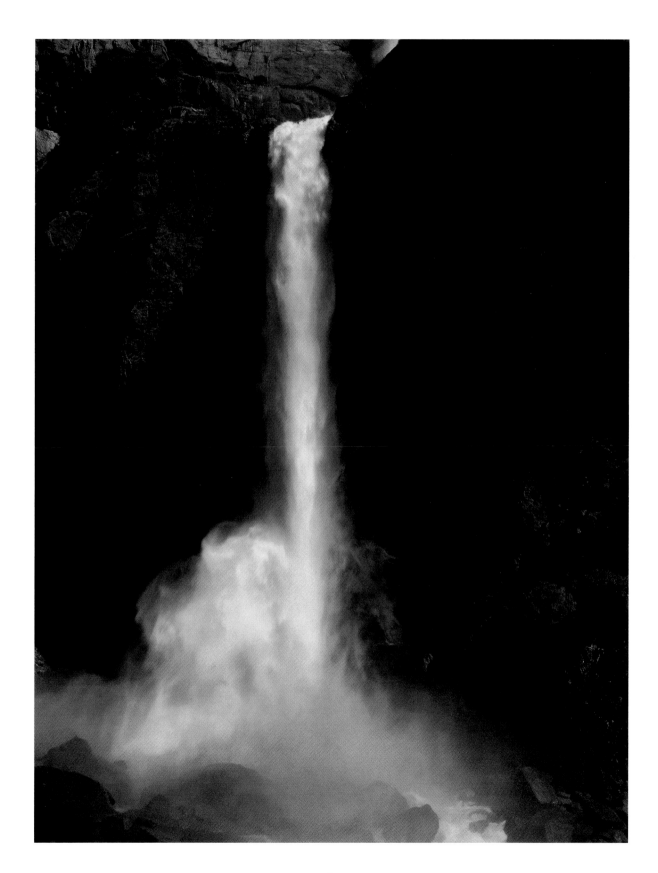

Upper Yosemite Falls, from Fern Ledge, Yosemite National Park, California, 1946

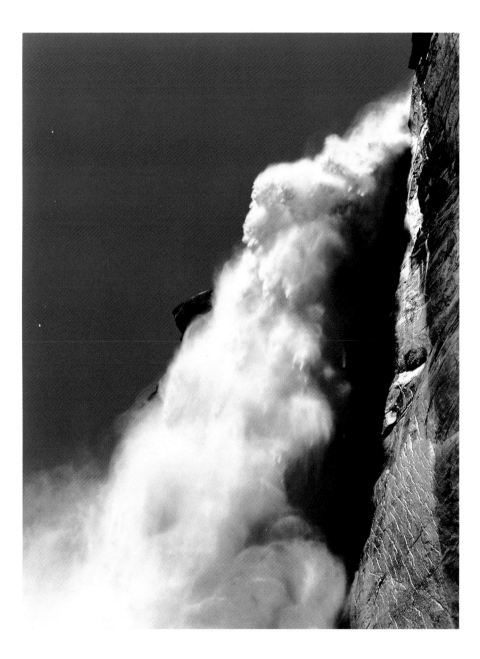

Salt Pools, near Wendover, Utah, c. 1947

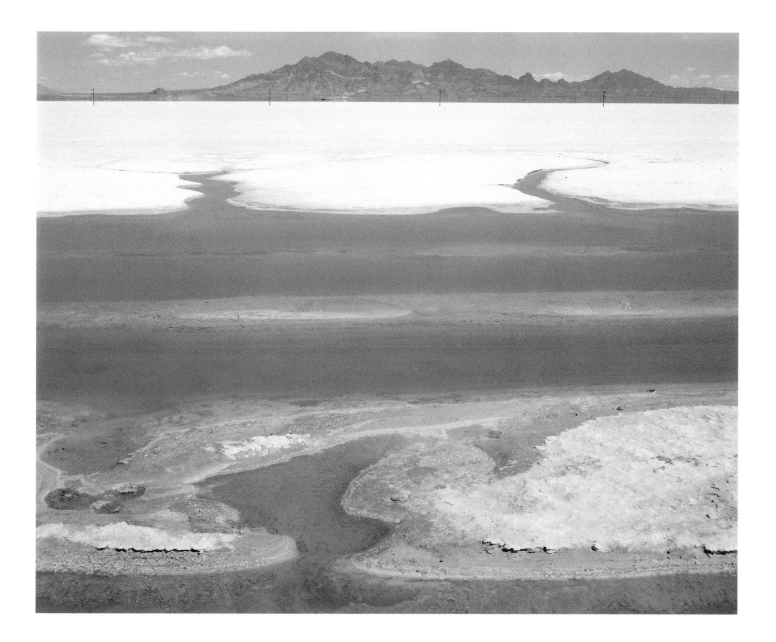

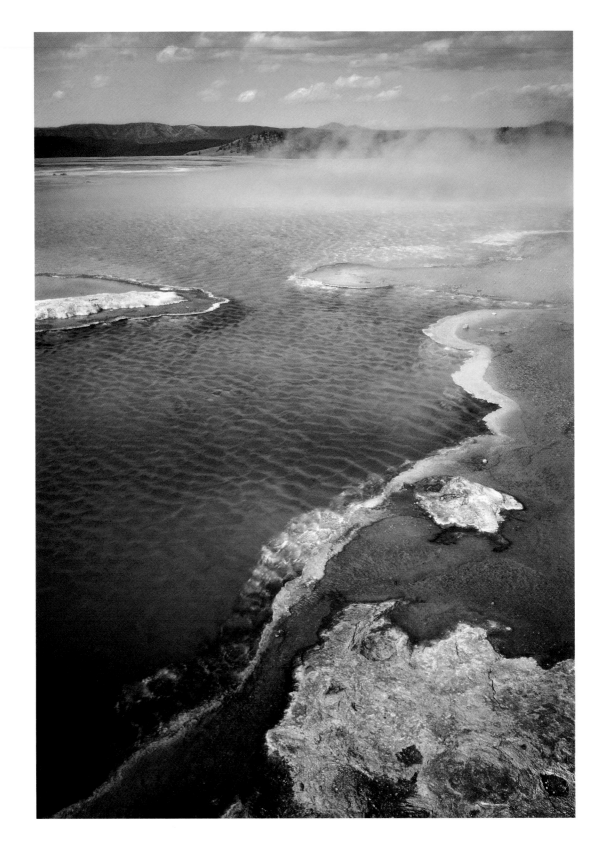

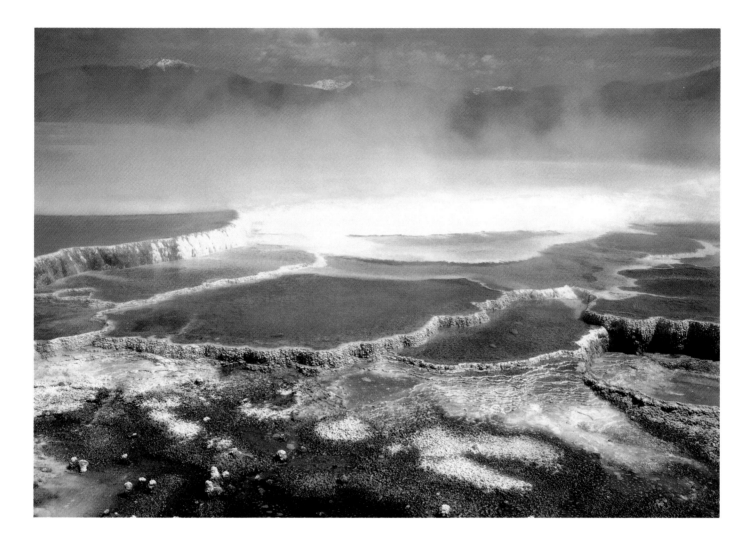

Detail of Mammoth Pool, Yellowstone National Park, Wyoming, 1946

Pool Detail, Yellowstone National Park, Wyoming, 1946

Mono Lake, White Branches and Clouds, California, 1947

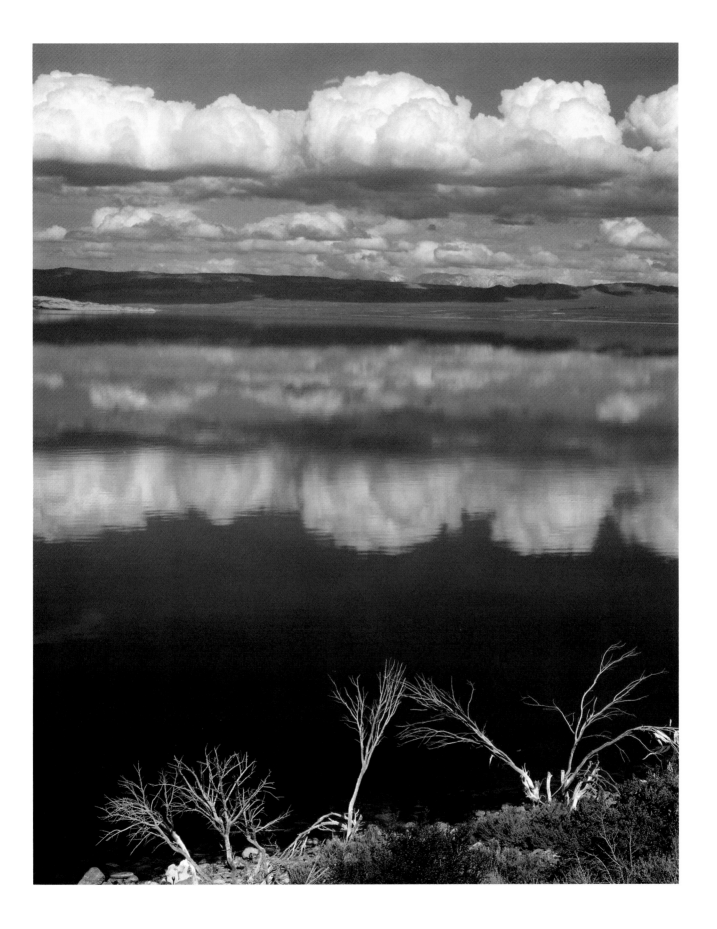

Caladium Leaves, Foster Botanical Gardens, Honolulu, Hawaii, 1948

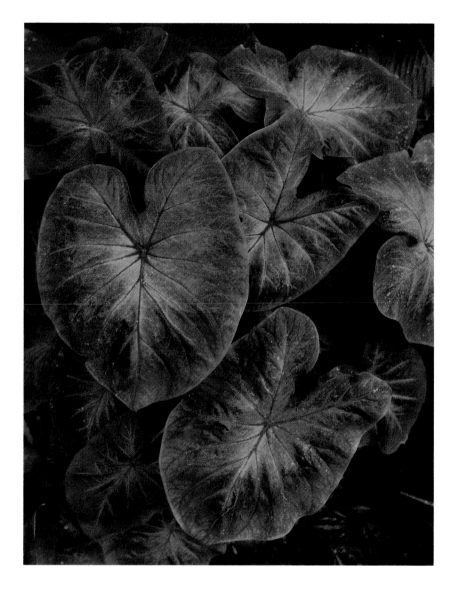

Bad Water and Telescope Peak, Death Valley National Monument, California, c. 1947

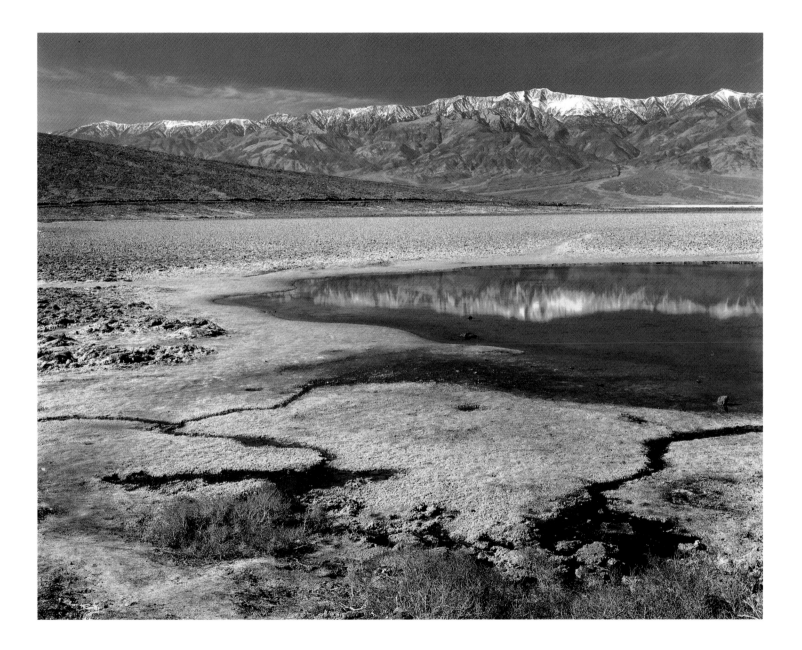

Vertical Cliff, Zion National Park, Utah, 1946

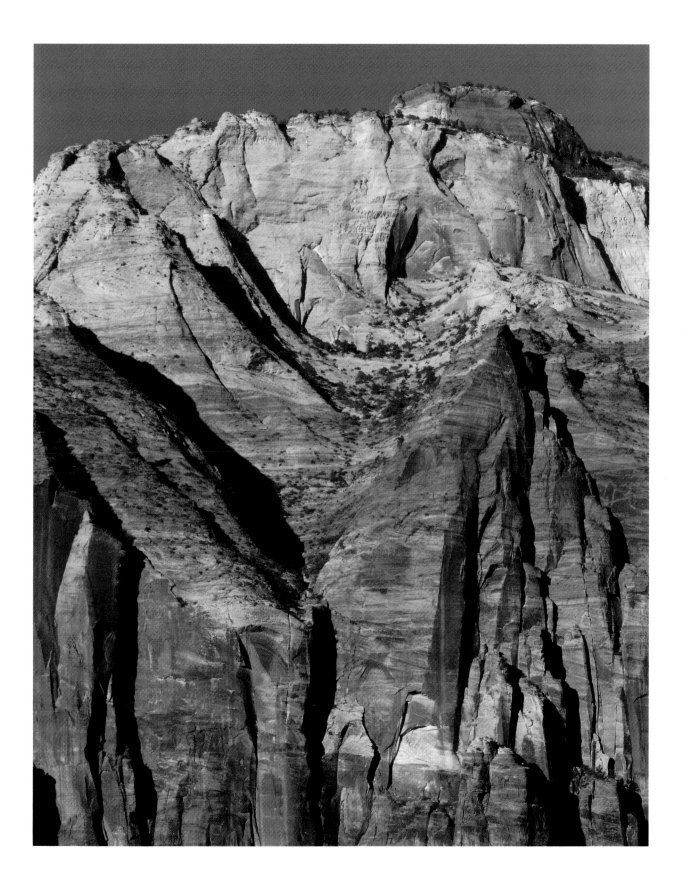

From near Sandy Cove, Glacier Bay National Monument, Alaska, 1948

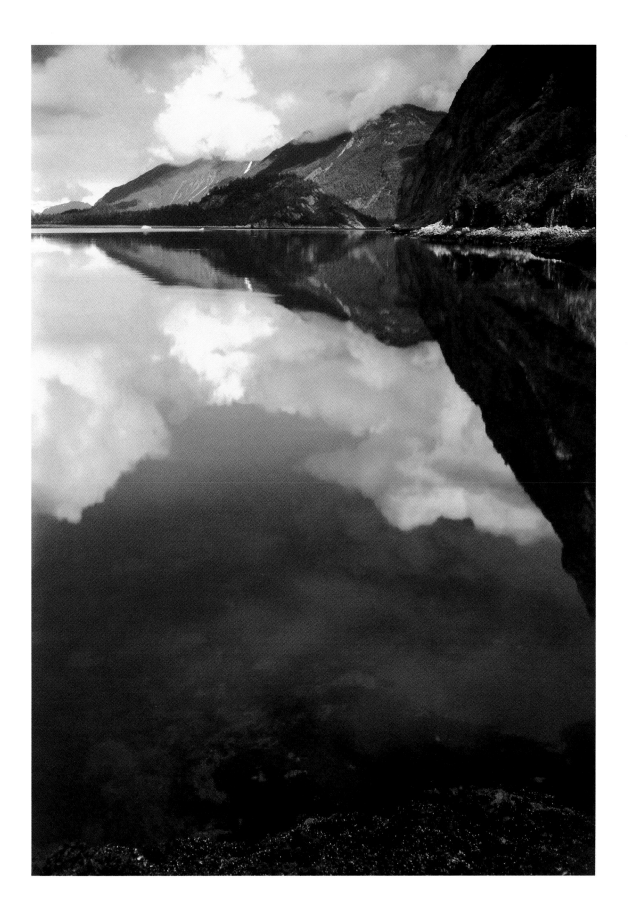

Lone Pine Peak, Winter Sunrise, Sierra Nevada, California, 1948

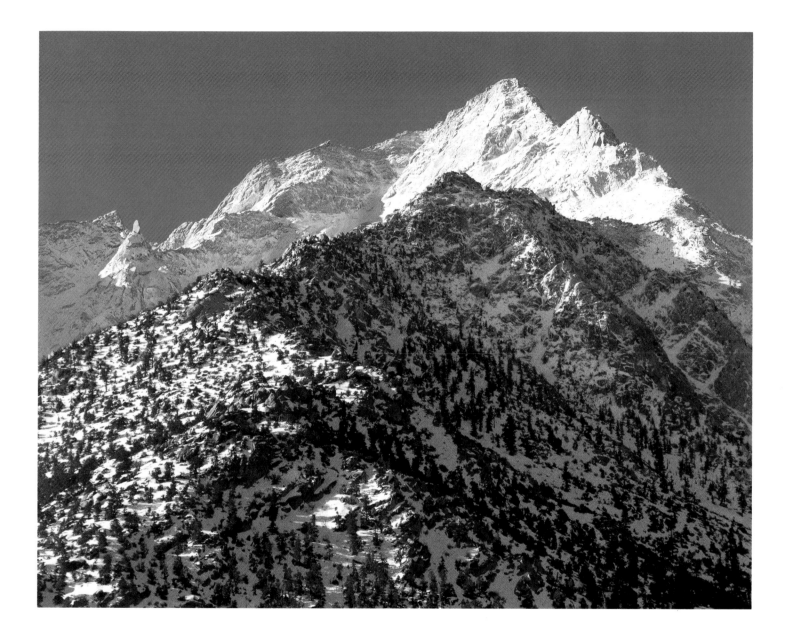

Wizard Island, Crater Lake National Park, Oregon, 1946

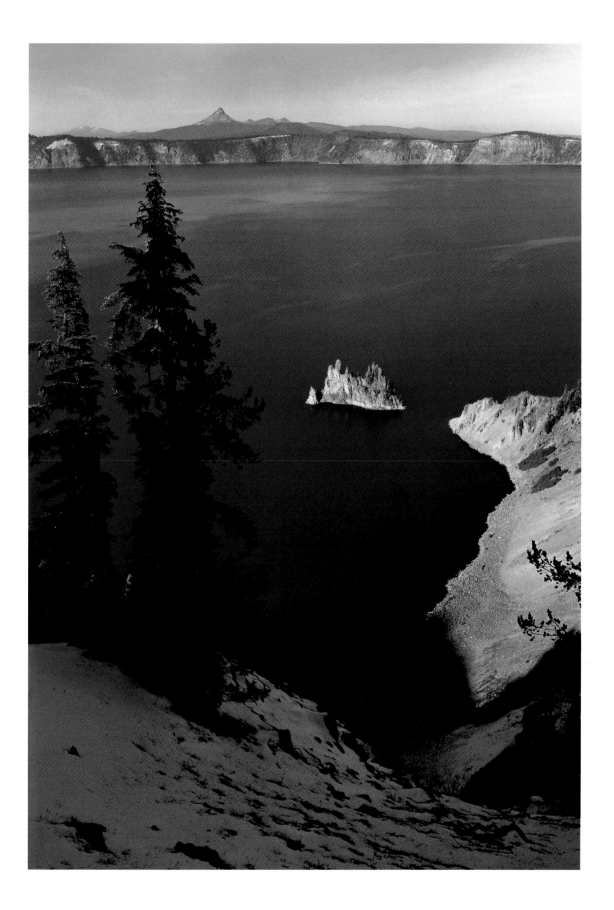

Winter Forest, Fresh Snow, Yosemite National Park, California, 1948

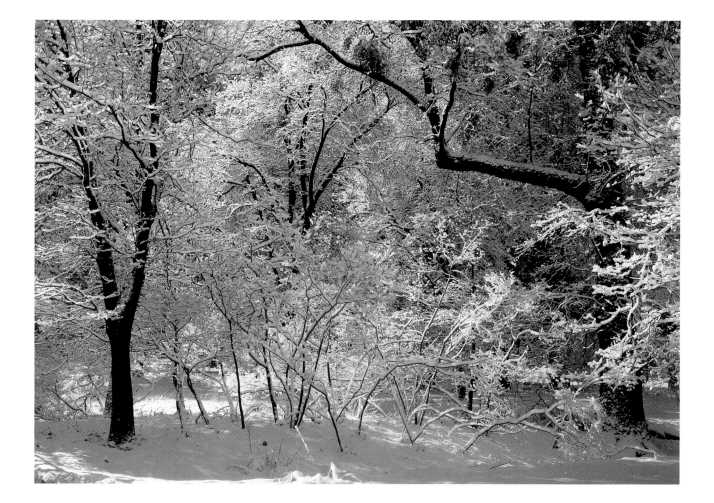

Ice Bow, Death Valley National Monument, California, c. 1960

Mauna Kea from Mauna Loa, Hawaii, 1948

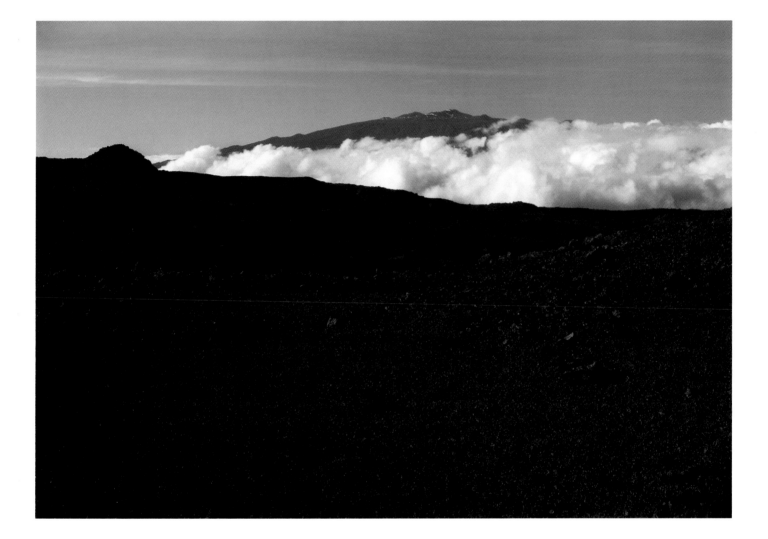

White Sands National Monument, New Mexico, c. 1947

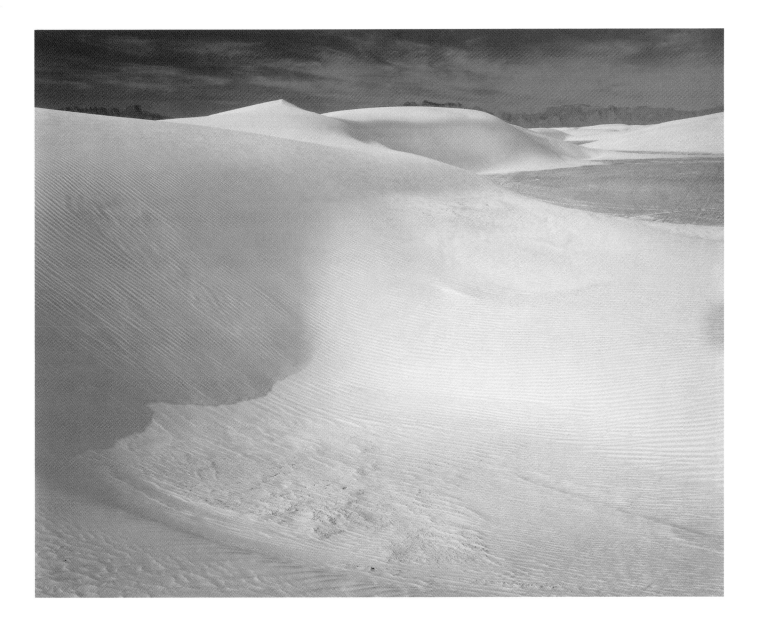

Manley Beacon, Death Valley National Monument, California, c. 1952

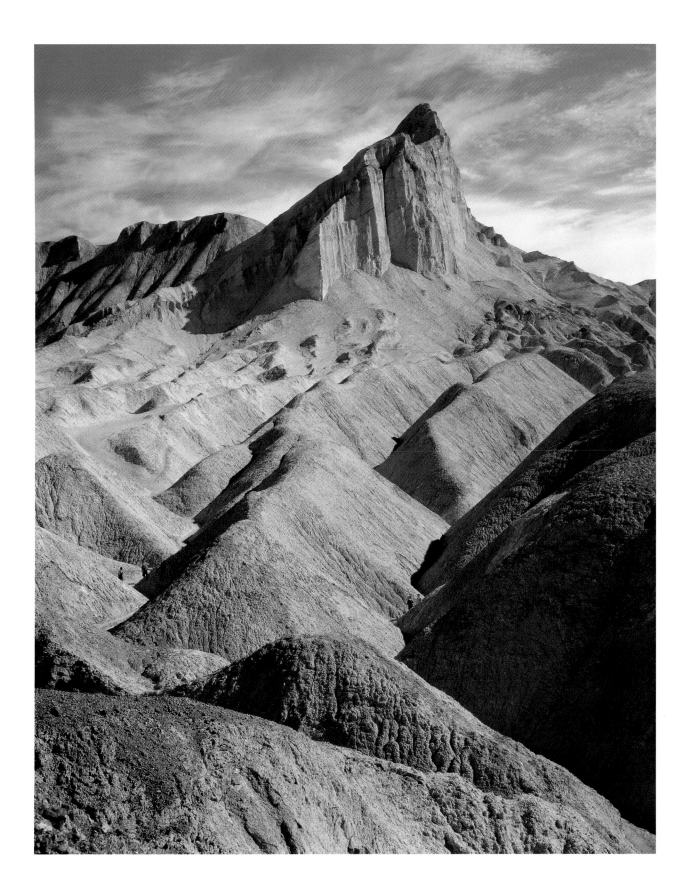

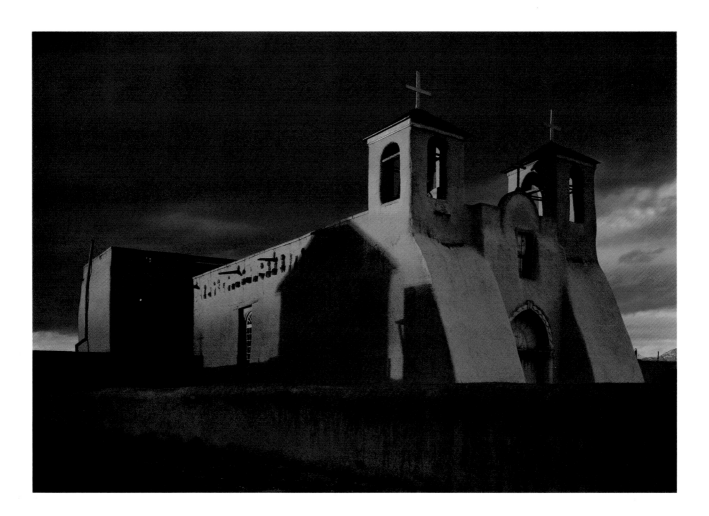

Church, Sunrise, Front, Ranchos de Taos, New Mexico, c. 1948

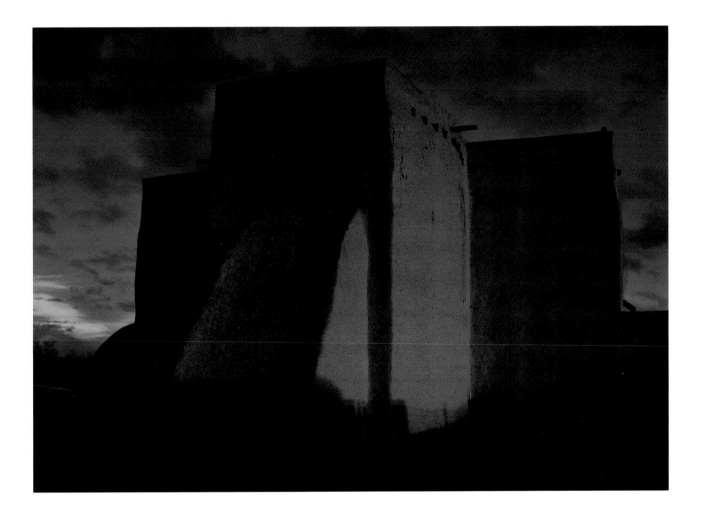

Church, Sunset, Rear, Ranchos de Taos, New Mexico, c. 1948

Papoose Room, Carlsbad Caverns National Park, New Mexico, c. 1947

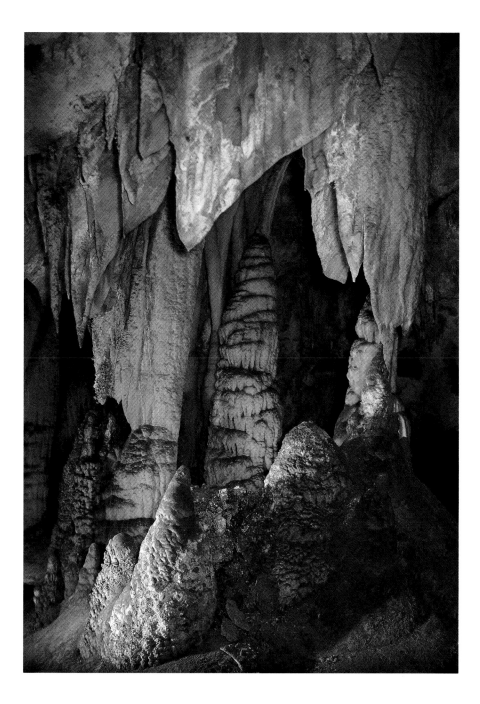

Monument Valley, Utah, c. 1950

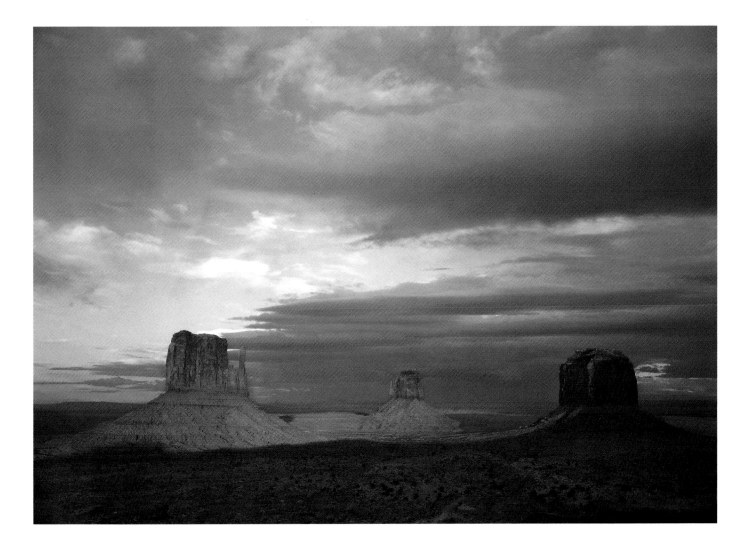

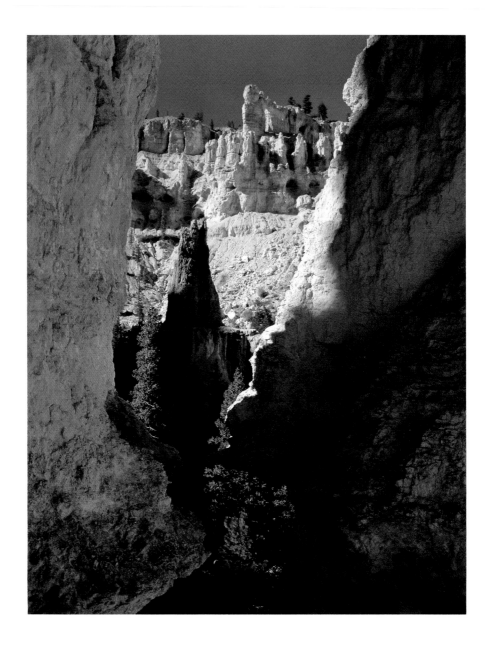

In Bryce Canyon, Bryce Canyon National Park, Utah, 1944

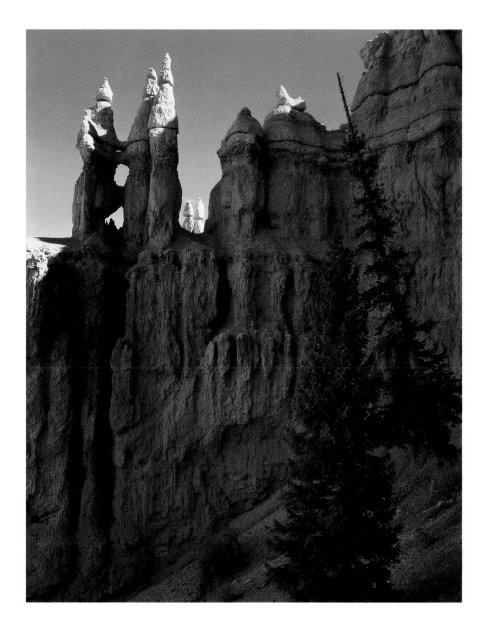

Cliff Detail, Bryce Canyon National Park, Utah, 1944

Late Evening, Monument Valley, Utah, c. 1950

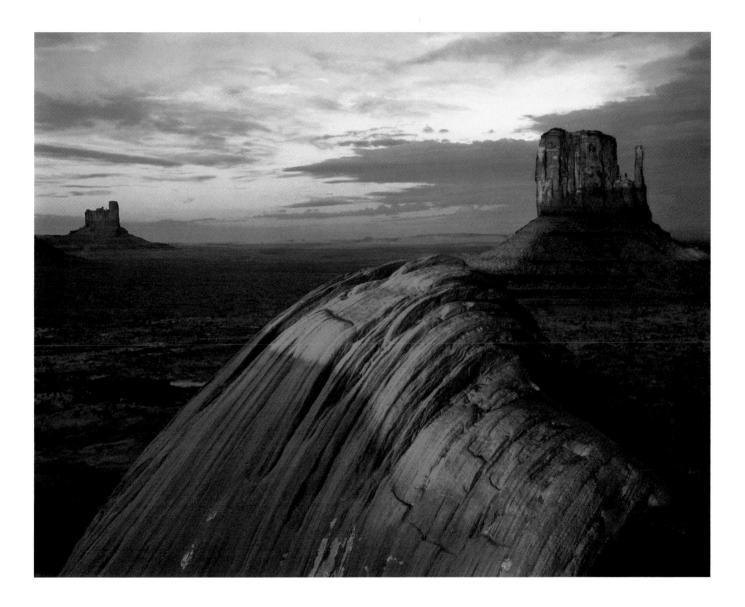

Autumn Forest, Twilight, Yosemite National Park, California, c. 1950

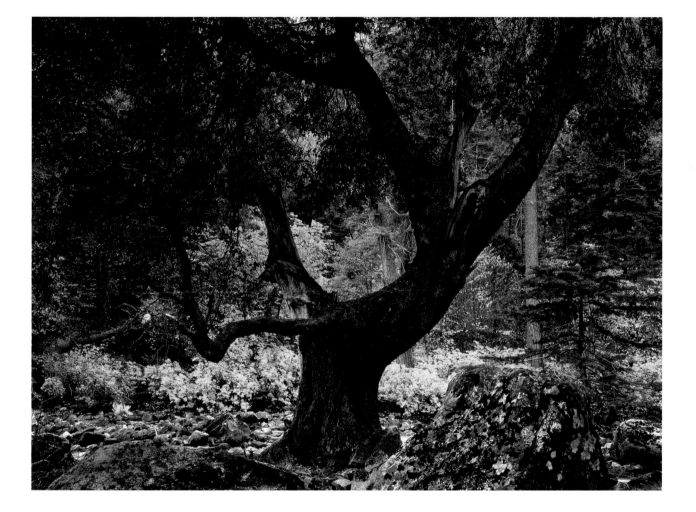

Landscape, Fall, near Aspen, Colorado, 1951

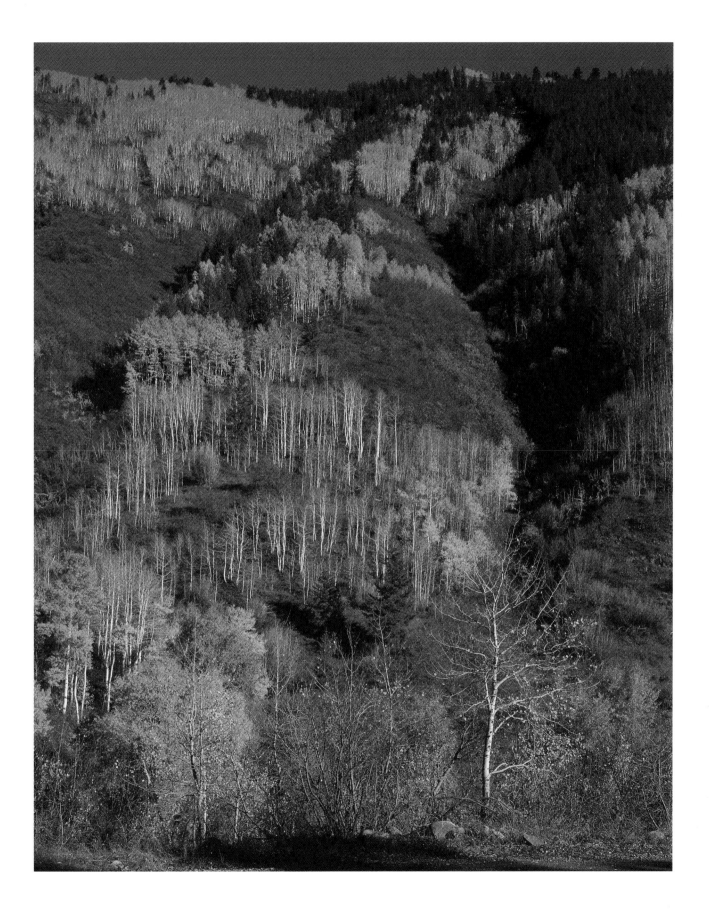

The Grand Canyon, Grand Canyon National Park, Arizona, 1947

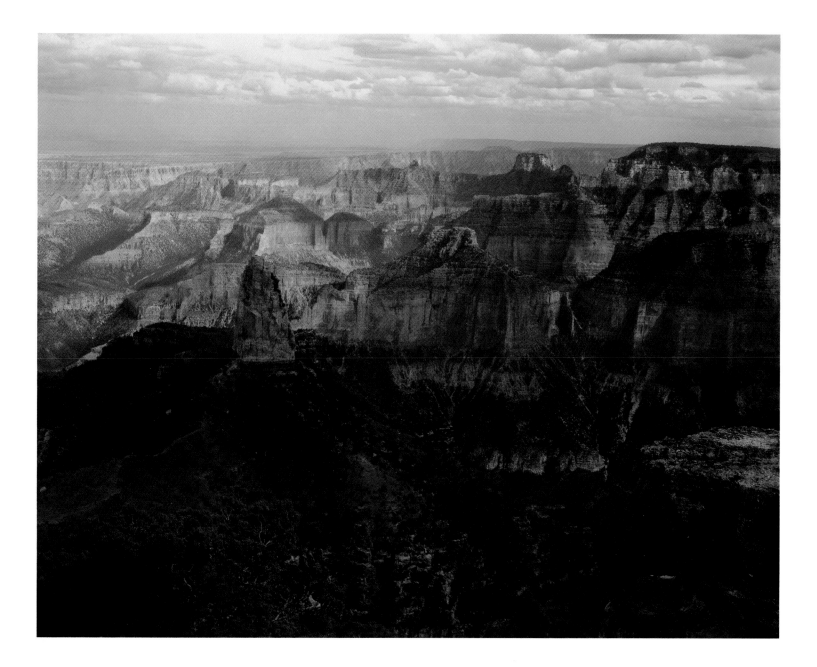

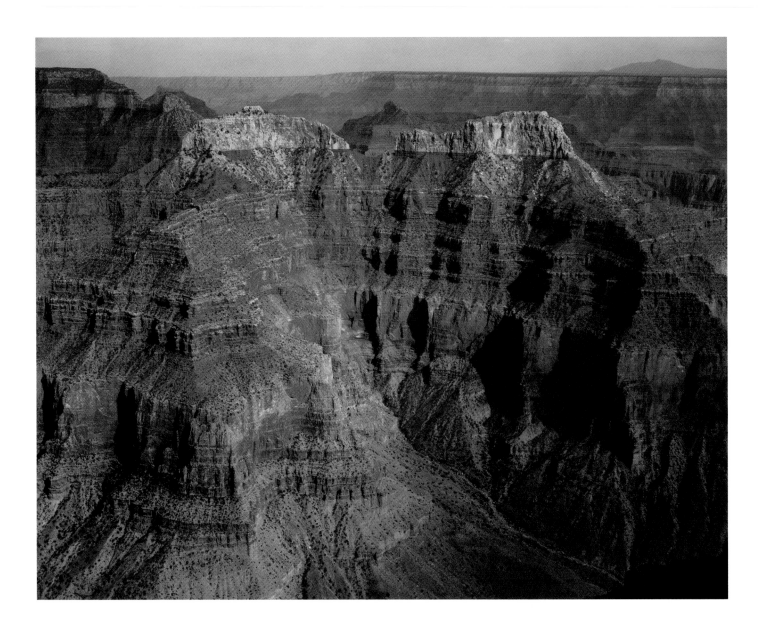

The Grand Canyon, Grand Canyon National Park, Arizona, 1947

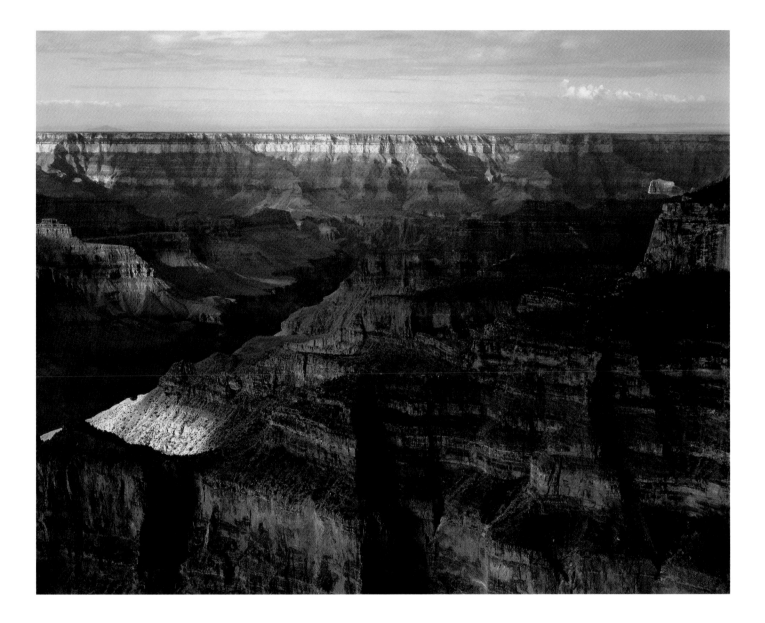

The Grand Canyon, Grand Canyon National Park, Arizona, 1947

Sunrise, Telescope Peak, Death Valley National Monument, California, c. 1952

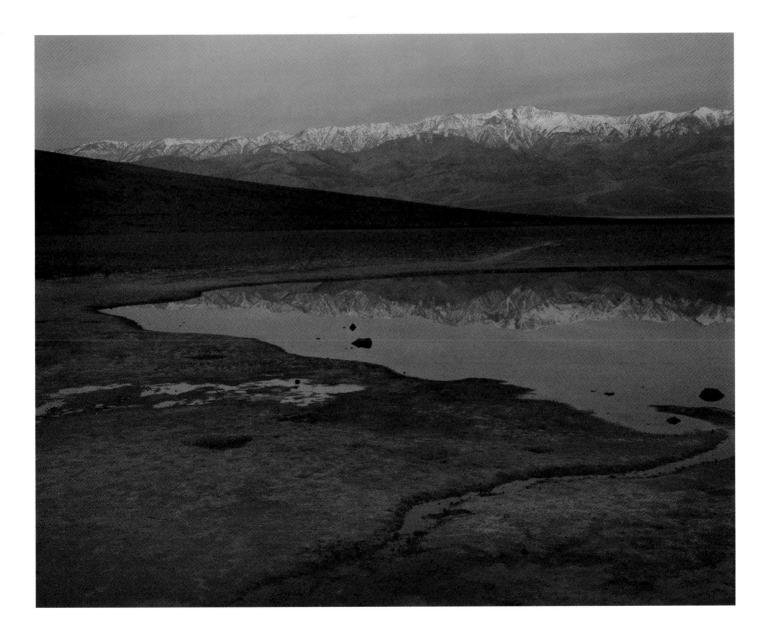

Selected Writings on Color Photography by Ansel Adams

I had hardly done half my developing when I got the notion to try a color plate of our garden, which is very attractive now with all the dahlias (about three hundred plants) in full bloom. So I purchased a box of Auto-chromes, a color filter, necessary chemicals, and a pamphlet of directions, and proceeded to expose four plates. I got *one* good one, and *three* worthless ones. Besides, I dropped the new filter and busted it. A rather expensive trial, I must say, but now that I have the "hang of it," I will do better. Those Autochromes are without doubt the highest mark in photographic science to date, but are still impracticable for general use. Perhaps we will soon be printing in colors — we hope so, anyway, for to have but one transparency, and not able to reproduce it is hard times when you wish to give one away. However, the ordinary black and white photographs are all right, and you can make a million prints, not dollars, off one negative if you wish.

From a letter to Virginia Best (Adams' future wife), September 1921

Incidentally, I have some color pictures of the Autumn Coloring in Colorado that make me feel that Color photography has possibilities for me. I want you to see these, too.

From a letter to Alfred Stieglitz, November 12, 1937

I also tremble when I think of the coming tornado of "color." But that remains to be seen. Perhaps it will be possible to pass a miracle and discover a color process that one can control. Ansco have sent me color film to try, and, confidentially, I can't see much practical difference in outside stuff — except that it has the one advantage of

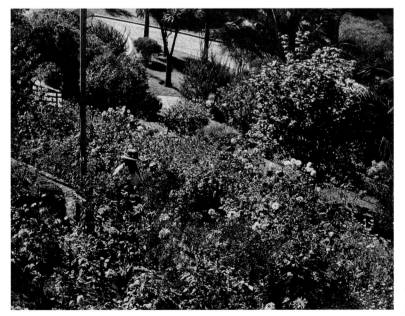

Autochrome of Olive Adams in her dahlia garden, San Francisco, California, 1921

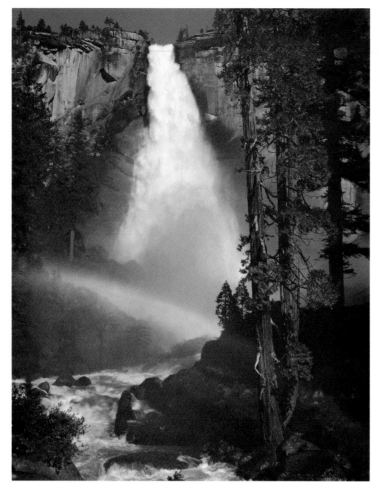

Nevada Fall, Rainbow,
Yosemite National Park,
California, 1946

being a little "softer" — but so damned little!!!! than Kodachrome.... I got some good Kodachromes on the recent trip from L.A. to Yosemite. The good ones are all non-literal in color.

From a letter to Beaumont Newhall, July 6, 1944

High Ho!! Believe it or not the Eastman Kulak (I mean Kodak) Co. are paying me $250.00 per shot for at least three 8 x 10 Kodachromes of Waterfalls mit Rainbows! (No discount if there ain't no rainboo!) Some new experimental film. HUshhhhhhhhhh. So, next week I go off to that hole in the ground Yosemite and click some shutters.

From a letter to Beaumont and Nancy Newhall, April 29, 1946

Got some magnificent 8 x 10 Kodachromes for the Eastman Kodak Company — they took five! Waterfalls with Rainbows, Big Trees, etc. Really quite pleased! Got $250.00 each, plus fifty sheets of 8 x 10 film, plus having my lens opticoated for nuttings! Now have enough cash to buy film for Guggenheim (Stipend will barely cover travel expenses....)

From a letter to David McAlpin, June 1946

This is a combined functional trip, as follows:

A. Kodachromes for Standard Oil

B. Kodachromes and Ektachromes for Eastman Kodak Company

C. Black and whites for FORTUNE

D. A sniff at some Guggenheim material

E. A vacation for Virginia and Mike

My schedule is as follows:

Yellowstone National Park Sept. 27–8 Wyoming

Glacier National Park Sept. 29–Oct. 6 Montana

…This tour should net enough cash to carry me for quite a while. Two jobs for Eastman have netted more than entire Guggenheim stipend. But find I can't combine creative and commercial work.

From a letter to Beaumont and Nancy Newhall from St. George, Utah, September 22, 1946

Got some gorgeous color things on the trip. One Ektachrome at Zion Park is the G-DambnestSOBchen wonderful thing I ever did. [See page 79.] With 26″ lens, just a detail of brilliant colored cliff. WOW!

From a letter to Beaumont and Nancy Newhall, October 27, 1946

Must entrain for Tucson next week to do another job for Eastman. Now they want me to do things for them at Acadia Park in Maine, and some general autumn things in the east! So, I will be able to afford this part of the Guggenheim, too!

From a letter to Beaumont and Nancy Newhall, July 13, 1947

Just returned from a scorching trip to Tucson by train.… It was a mere 108 plus in the shade at Tucson. Got some good things for EK I hope. EK was delighted with the Bryce pictures—took 5 of them. And, seeing as how they want me to take some things for them in the East, it looks as if the Guggenheim can actually be afforded!

From a letter to Nancy Newhall, July 19, 1947

I was camped in my car near Stovepipe Wells, usually sleeping on top of my car on the camera platform, which measured about 5x9 feet. Arising long before dawn, I made some coffee and reheated some beans, then gathered my equipment and started on the rather arduous walk through the dunes to capture the legendary dune sunrise. Several times previously I had struggled through the steep sands with a heavy pack only to find I was too late for the light or I encountered lens-damaging wind-blown sand. The dunes are constantly changing, and there is no selected place to return to after weeks or months have passed.

A searing sun rose over the Funeral Range, and I knew it was to be a hot day. Fortunately I had just arrived at a location where an exciting composition was unfolding. The red-golden light struck the dunes, and their crests became slightly diffuse with sand gently blowing in the early wind. To take full advantage of the sunrise colors on the dunes I worked first with 4x5 Kodachrome.… Then, without moving the camera, I made several exposures with black-and-white film.…

Within fifteen minutes the light flattened out on the dunes and I moved back to my car through 90°F and more of the Death Valley heat....

Description of taking Sand Dunes, Sunrise, Death Valley National Monument, California *in 1948; from* Examples: The Making of 40 Photographs *(Boston: Little, Brown and Company, 1983), pp. 57–58*

Believe it or not—another book Idea for 1951!! The proposition was first discussed this morning, and at 4 PM I was asked to write you about it. Briefly, it is this:

Roland Meyer, who has produced the *Standard Oil Scenic Views of the West* series (which was one of the most popular advertising campaigns in recent years) tells me that Standard Oil is anxious to take up the series again. The separate views are one thing, but the idea of a book on the National Parks—chiefly in color—and with definitive text by a well-known writer stimulated their attention.

The proposition discussed follows:

1. I have hundreds of factual pictures of the Parks—both black-and-white and in color—which will not be used in MY CAMERA IN THE NATIONAL PARKS....

2. Now,...the Standard Oil Company of California entertains the idea of doing such a book (with emphasis on color). The title page would be something like this:

THE NATIONAL PARKS—OUR NATIONAL HERITAGE
Text by Bernard De Voto
Photographs by Ansel Adams…

...

4. Without commitment on your part, will you tell me if you think this idea has merit. If so, it will give me something to work on. I have most of the pictures; nothing need be done on the photographs until the present books are finished. If the idea interests you, we will go after De Voto and work out some basic plan. It will be a *popular* book and in no way conflict with the MY CAMERA series.

Letter to Paul Brooks, Editor, Houghton Mifflin Company, January 18, 1950

I have done the Poppy Colorama [see page 19]; that is, I have made the pictures—and I hope to Gawd they like them! The conditions were absolutely antagonistic throughout. My Primeval World is letting me down! The people were OK, but the weather and the dearth of poopies! I still have the national ad to do, but I am scared to death of it as it is very hard to find anything lush hereabouts. I went well over 3000 miles looking for suitable areas. I missed one or two that were short-lived and doing their stuff while I was looking elsewhere. But it is a big state and poppies are scarce.

From a letter to Nancy Newhall, April 18, 1951, about Kodak advertisements

...Some people feel I am prostituting my very eternal soul in doing the various commercial jobs I am doing. Let *them* pay the bills! If my damned photography ain't strong enough to stand some bread and butter loads, to Hell with it!

From a letter to Nancy Newhall, July 23, 1951

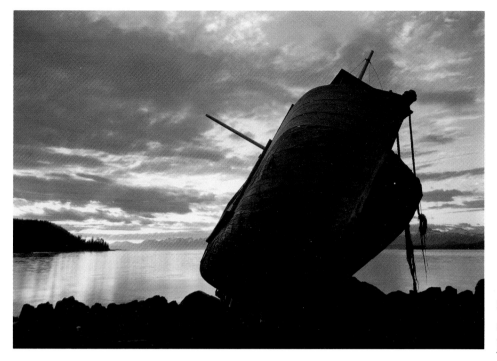

Shipwreck of the Ark
at Salt Chuck, near
Juneau, Alaska, 1948

...This job is a difficult one, and I do not have much energy left for expressive writing. Up this AM at 4—it is now 11 PM. Up tomorrow at 6—the mine is nearly forty miles away; it takes an hour in a "Speeder" (a rail car) to reach the various levels. But the "Pit" is a tremendous thing—mountain in scale and mood.

> From a letter to Beaumont and Nancy Newhall, August 14, 1951, about photographing at the Anaconda Copper Mine in Salt Lake City, Utah

...I apparently got some good things this last trip—although I did fizzle on the Poppy ad (the poppy colorama seems fine). But I did get a magnificent swimming-pool picture—best job I ever did of its kind. It may have national advertising possibilities. At any event I have to do for George [Waters, of Kodak] the following:

> 6 scenic Ektacolors
> 6 black and white mural subjects
> 1 Sunset Colorama
> Colorama sketches (ideas)

Confidentially that totals to about $3,400.00 so my late fall and early winter will have some nuts in the burrow!

> From a letter to Beaumont and Nancy Newhall, August 22, 1951

As for the comments about me and Kodak, etc. Much appreciated!!!!! It would be wonderful to have a stipend from Kodak! There is no conflict with Land—especially if I could function as a creative person. With the Land contract I am primarily a research (field) person. It seems to me that I could function best with Kodak by merely doing a minimum amount of creative work for a given stipend (that is, a guaranteed number of creative pictures). There would always be more than stipulated—but it could give me the chance to do a lot of creative field work—

and the pictures could be integrated into the Kodak plan advantageously for them. I suppose it would be largely color work. I WOULD like the chance to do creative color.

From a letter to Nancy Newhall, December 13, 1952

Understanding photography in any of its myriad aspects is exasperatingly difficult because of the inherent conflict between symbolism and the simulation of reality. We accept a painting for its own objective qualities. "Realistic" or "non-objective," it remains primarily an *object*, created entirely through the eye, mind, spirit and heart. We may agree, then, that painting is, in the best sense of the term, a synthetic art. The world is observed, felt, integrated, transcribed and transposed, formalized and reborn on a sheet of paper or canvas. The painter and his esthetic and emotional message remains paramount; the subject of the painting — if it comes through at all — is but a part of the chain of events of creative expression. Few will check the accuracy of depiction of an early Renaissance landscape, yet we are amazed by the pseudo-realistic inventions of a Harnett or a Dalí; nevertheless we grant the artist the privilege of sincere emphasis or exaggeration.

Excepting the photogram, and questionable "combined" images, the photograph is always bound to the performance of the camera. Alter the lens-to-subject distance, the focal length of the lens, or the proportions and size of the negative, and — in reference to a given viewpoint — we are still recording only what is optically logical in relation to these conditions. Next, our sensitive materials render a restricted scale of image values in terms of subject brightnesses. The rendition of color values in black-and-white photographs is controllable within limits, but we must admit that we accept certain renditions which are but symbols of reality. In the early days of blue-sensitive plates skies were white, and reds and greens were quite dark. Now, with panchromatic films and appropriate filters, we achieve dark skies and light reds! Both can be emotionally and esthetically valid: the white sky creates the illusion of *light* and the dark sky establishes value and tonality. But within the rigorous limitations of the medium we can — if we have sufficient command of craft, imaginative perception, and the capacity to visualize the final image before the exposure is made — create authentic art. Examples attesting to this statement are available in the work of Stieglitz, Strand, Weston, Smith and a few others of the present day.

Everything said about black-and-white photography pertains to color photography, with the addition that a more precise technique is demanded as well as a refined sense of colorful *color*, and not just as a play of dyes on a piece of film. The temptation is to take advantage of superficially exciting color; "if you can't make it good make it red" has unfortunately become more a fact than a merely funny remark!

It is my personal opinion that as photography approaches the simulation of reality it withdraws from the esthetic experience of reality. I except here the work of Clarence Kennedy who has re-created with the most astonishing perfection, in large color stereos, Renaissance sculpture and painting. But here the subject possessed an enormous esthetic potential; the same re-creation of reality with ordinary objects would undoubtedly evoke merely an admiration of craft, and an esthetic-emotional response based on the intense revelation of a segment of the objective world. This, to me, is insufficient. Some underlying spiritual recognition and motive is required.

Apart from what is seen and how it is restated, we are faced with an interesting confusion in color photography. A color transparency, viewed against diffused light or projected on a screen, creates an extended contrast range compared with the original subject. A color print or a printing-press reproduction presents a reduced contrast range compared with the original subject (or transparency). With subjects of low inherent contrast and dilute colors the possible simulation of reality is greater than with subjects of normal or high contrast and strong colors. Esthetically,

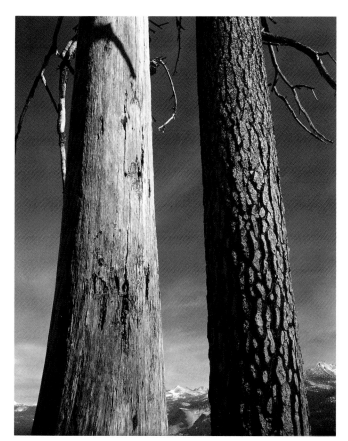

Trees, Washburn Point, Yosemite National Park, California, c. 1946

subjects possessing the least obvious color seem to come through best — not only in simulation of reality but in sheer beauty of color in image. A departure from reality in terms of color involves a shock; unless this departure is so completely stylized as to be truly unreal there may be little esthetic satisfaction obtained.

The esthetic response is extremely complex, philosophically and psychologically, and is firmly bound to personal experience. Cultural background, nostalgia, response to color, craft conscience, and the magical perceptive abilities of the creative artist must all be considered. Whitehead said "Perception is recognition." The true artist, once he has perceived and visualized, can transmit his recognition with any means at his disposal. The recent work of Ernst Haas opens new vistas of perception and execution with the color camera. His "recognition" becomes our experience!

My own reaction to color photography is a mixed one. I accept its importance as a medium of communication and information. I have yet to see — much less produce — a color photograph that fulfills my concepts of the objectives of art. It may approach it, give pleasure and induce contemplation, but it never seems to me to achieve that happy blend of perception and realization which we observe in the greatest black-and-white photographs. I believe that color photography, while astonishingly advanced technologically, is still in its infancy as a creative medium. We must remain objective and critical, plead for greater opportunity for control, and constantly remind ourselves that the qualities of art are achieved in spite of conditions and media — never because of them.

From "Color Photography as a Creative Medium," Image, *vol. 6, no. 9 (November 1957)*

In thinking about the "accuracy" of color photography, we should review the characteristics of photography in general in terms of representation and interpretation. Black-and-white photography is accepted as a stylized medium; values are intentionally accented or subdued in reference to their "photometric-equivalent" value. There is little or no "reality" in the blacks, grays and whites of either the informational or expressive black-and-white image, and yet we have learned to interpret these values as meaningful and "real."

With color photography we are introduced to a more potent "trap of reality," and this fact is accentuated when we can make an immediate comparison of the color print with the subject. With conventional color photography, there is always a delay between the making of the exposure and seeing the final product (transparency or print). Comparisons are made with memory rather than with fact! If the colors do not distress us by obvious falseness or poor aesthetic relationships, we accept the conventional color picture as a statement, a symbol, or even as a *record* of the subject. In my experience, no color photograph will convey a truly *accurate* interpretation of the subject although one color may be more satisfactory than the others.… The accuracy of the color photograph is more a matter of belief than of actuality. This fact is not appreciated by many photographers because a direct and immediate comparison is seldom possible. Adjustments are required when we make direct comparisons of the Polacolor print (and any other color print) with the reality we have photographed. I am sure we will learn to appreciate a color photograph as an aesthetic experience — a statement in values and colors which will evoke affirmations of mood and spirit — as well as an interpretation of the world of which we are a part. Psychologically any one color is affected by other colors, by changes of light quality and intensity, by the inherent contrast of the scene, and also by the objective qualities of the subject and the subjective reactions of the photographer.

The miraculous computer which is our eye-mind-psyche complex perceives exquisitely small differences of value and color and can instantly develop a condition of acceptance or rejection, or of comprehension or bewilderment. The "equations" are always solved in some creative way. We must not force ourselves into firm opinions of this new process; we must allow it to work for us and with us. We will have need to experiment — to see color relationships rather than just accidental arrays of colored objects and to sense the appropriate level of exposure which will yield desired values, textures and contrasts. We will need to know the subtle change in color and contrast that slight changes in the processing time may produce, and to know when and how to use light-balancing filters, reflectors, fill-in illumination, etc. Above all, we must become aware of the advantages and limitations of color photography in general in relation to both the simulations of reality and the adventures of departures-from-reality.

Excerpt from a draft of an article on Polacolor, December 8, 1962

I am a close personal friend of Eliot Porter. It was I who suggested this book to the Sierra Club. It is a magnificent job — a great message and the revelation of a dedicated spirit.

However, I have never been able to adjust myself to color photography. I do not understand it. It would be false for me to attempt a review, because I simply would exhibit the fact that I did not know what I was talking about. What Porter saw, what he felt, how he trimmed his creative sails to the sharp winds of Thoreau, — all these things are self-evident! Anything further I could say would be a kind of lily-painting. But a ghostly lily-painting job at that, because I basically, deeply, fundamentally don't like the lily-painting which IS color photography.

NO you *can't* print this letter!…

From a letter to John Irwin, publisher of Artforum, *December 13, 1962, in which Adams declines to review Eliot Porter's new book* In Wildness Is the Preservation of the World *(San Francisco: Sierra Club, 1962)*

My gal dug out some color and here it is. Many are really "early" images — on the first Kodachrome. I have done little color of late. I have not done well with Polacolor — but Marie Cosindas carries the halo in that (some of her things are truly remarkable). Someday I shall really try for color; the transparencies interest me deeply, but the ordinary prints and reproductions create a sense of disturbance and uncertainty (from the esthetic point of view). The Polacolor prints please me more than any others, esthetically, because there is a basic relationship of color values — none of the garish, forced effects which seem to come from intense dyes. As time goes on, however, I feel more and more the magical expressive qualities of a beautiful black-and-white image, probably because black-and-white is fundamentally a departure from visual "reality." Most of the color photography I have reacted to relates to the subject more than to the photographic expression; studio arrangements and lighting, and images of sheer overwhelming power of subject which come through independently of the medium. Also, the small and subtle details of nature and of the works of man which, because they have been carefully selected and isolated, partake of some esthetic and emotional experience.

Most reproductions are terrible. Occasionally a fine reproduction quality comes through (I feel LOOK is superior in this way) and this may not have anything to do with the "visual reality" of the subject; it creates a simple independent esthetic effect.

Many of the enclosed transparencies are very valuable. Please tell people to be careful. My best wishes. More soon.

Letter to David Vestal, editor of Popular Photography, *February 6, 1967*

I cannot adequately explain why I prefer black-and-white photography to color photography, although I certainly have a very strong reaction to most color photography I have seen. I was trained as a musician and — after ten years of hard work at the piano — I was able to exercise an accurate and consistent *control* of tone values, phrase shape, and dynamics. When I was drawn into photography I naturally demanded two qualities: one, an adequate mechanical technique and two, a high order of consistent expressive control of values. This was, of course, a reverberation of my music experience; one simply cannot be sloppy in music.

When Kodachrome first appeared, I was, of course, entranced with the possibilities. I made countless 35mm slides and — for those early days — some of the results were pretty good. The projected slides did have great life and brilliance and a logical level of color values. All have disintegrated by now, but I can still recall some very vivid impressions of New Mexico scenes — aspens, clouds, adobes and people.

I soon tired of the color slides because I discovered that I had very little control of values; a little under- or a little overexposure, perhaps some CC filters bound in with some slides to overcome some garish exaggerated color effects. All the prints I have seen are very inadequate for me, excepting some fine carbros which really had a "pigment" feeling instead of the thin and garish "dye" quality. Even to this day I have a squeamish feeling about color prints; the values are simply not in key. I like the Polacolor prints because the color is much more suave and "related" in values. I thoroughly dislike "abstract" color photography that merely apes abstract painting!

I suppose that with black-and-white the photographer can make really great "departures from reality." The medium carries its own convictions, has its own quality of values and "image color." I can get — for me — a far greater sense of "color" through a well-planned and executed black-and-white image than I have ever achieved with color photography. We are talking about extremely subtle distinctions that may not make sense to anyone who is not sensitive to the infinite scale of values which fine black-and-white photography can achieve. For me, the *projected* color images are most valid, and I hope someday to be able to do some new work in this direction.

From "Ansel Adams on Color," Popular Photography, *vol. 61, no. 1 (July 1967)*

In 1969 I face a peculiar and difficult world in terms of photography—a contradiction in terms of the medium in its present advanced state, and my rather simple approach. I am not alone in my quandary. Color photography pays off; color photography is immensely popular. All the aggressive professionals I know are deep in dye and transfer syndromes. Few inquire if the *color* and the color relationships have basic esthetic quality; the External Event usually reigns supreme. I prefer black-and-white photography chiefly because it offers imaginative controls and a powerful degree of stylization. As yet we do not have much effective control in color photography except in control of the subject-matter and the applied lighting.

However, were I starting all over again, I am sure I would be deeply concerned with color. The medium will create its own esthetic, its own standards of craft and application. The artist, in the end, always controls the medium.

From "A Photographer Talks About His Art," speech given at Occidental College, Los Angeles, 1969

We are having a Workshop in Yosemite in October; on CREATIVE COLOR, with Marie Cosindas and Al Weber.... As you know, I know nothing about color printing techniques. Marie will concentrate on her particular kinds of "seeing" and doing. Al will approach the more general color techniques. I will kabitz in a general sense.

You are very kind about offering to make a print! I shall look something up! I saw the Cibachrome results and I must say that I regret the process is announced as being permanent!! It was AWFUL!! Your prints shine like rare jewels in comparison. In fact, you ARE AWFUL GOOD!!

From a letter to Wally McGalliard, July 30, 1971

Thanks 10⁹x for the prints. They arrived just after I arrived from Yosemite.... I have signed the prints and am returning two to you as requested.... The title of this picture is REAR, RANCHOS DE TAOS CHURCH, NEW MEXICO. You did a spectacular job with it. The old Kodachrome was pretty strong in purples, etc.!!... I shall treasure my copy.

From a letter to Wally McGalliard, June 10, 1972, on receipt of three dye-transfer color prints made from Adams' transparency. (See page 97.)

It is most important to realize that the "composition" (visualization) of the color image is distinctly different from that of the black-and-white. Some of us instinctively "see" better in color. A good case in point is the experience the eminent color photographer, Marie Cosindas, had at one of my early Yosemite workshops. Marie was devotedly working with her 4x5 view camera and black-and-white film. On several occasions she would ask me to check an image on her groundglass. In each case she had a beautiful photograph but the values were soft and subtle and—as they would be rendered in quite similar values in the black-and-white print—the results would be drab and monotonous although the arrangements of shapes was sensitive and pleasing. I would say to her, "Marie, you are handling shapes in the format very well indeed but you are *'seeing' in color*; your visualization will not be realized in black-and-white...." It requires some thought and experience to realize that, for example, soft green moss, brown pine needles and gray rock will be rendered on unfiltered panchromatic film in approximately the same values of gray. In color photography these subtle hues may be clearly defined and "separated." The color processes allow us certain controls in intensity, or saturation; as a painter we can stress or subdue the relationships

of hues. With certain filters we can exaggerate or actually reverse the sensations of color. It is all a matter of visualization in relation to the film characteristics, the color of the illumination, choice of filtration, exposure and, to a certain extent, processing the color positive or the color negative and the prints therefrom.

Color, physically or psychologically considered, is extremely complex. While we have good reason to believe all persons with normal vision see colors the same way, the *significance* of colors may vary with each individual. Think of the palettes of the important artists, the distinctive colors of El Greco, of Cézanne, of Munch, Kandinski and Dove. In many cases an artist can be recognized by his color alone from a small fragment of his work. Of course, other factors, such as brush stroke, aid in the identification, but *color* can be the decisive key. We all have favorite colors and color combinations. I have a particular antipathy to tan and pink and a definitely negative reaction to strong cyans. Automatically in my color compositions, I avoid these colors; however, when I was doing professional advertising and architectural photography, I was often obliged to do the best I could with whatever color and color combinations I was confronted with.

From a manuscript for an unpublished book on color photography, August 24, 1979

The creative color photographer is faced with problems quite different from those encountered in black and white. The latter is, at best, an interpretive *simulation* of reality in monochrome. A color photograph reflects what many consider should be a realistic picture of the world in "true" color. This is, of course, a visual illusion; the real world is not duplicated in a transparency or on a sheet of paper. If we wish to believe it is we may be emotionally stirred by the subject alone. However, color *in itself* has a profound emotional potential. The problem facing the color photographer is how to combine the optical precisions with an imaginative and well-balanced organization in color. In no other graphic medium can color be so offensive as in the interpretation of, for example, "scenery."

The question of "true" color arises in discussion of the comparative qualities of color film and prints. "True color" is a fiction, a false assurance that the sky was "that shade of blue" or this portrait shows "correct" flesh colors and values. Superficially, some relationship between reality and image may be imagined; seldom do we intentionally distort colors (making the sky pink at noon, as it seems to be on Mars, or making normal skin values purple, or foliage red). However, such effects are used rewardingly in scientific exploration and interpretation of the earth's surface (as "false-color" photographs from space). Significantly, these "false-color" pictures are acquiring a rather broad acceptance and a certain aesthetic significance. They are both functional and beautiful in their own way.

Hence, I believe we should encourage non-real explorations into worlds of color hitherto restricted to painting. Only the technical rigidities and the fear of the unreal have held interpretive color photography to rather narrow paths. It now appears that the horizons are opening for new creative-emotional concepts that can be achieved in the domain of color imagery in the photographic mode.

"Trial on Color Photography — Introduction," for an unpublished book on color photography, December 19, 1981

I have worked with color photography since the advent of Kodachrome. In fact, around the age of twenty I made some Autochromes. These were not very good and were also quite expensive (for me). On entering professional work I did color in many ways; general advertising, catalogues, display, etc. I also did essays for Fortune, Life, Horizon Magazine and others. I did at least a dozen "Coloramas" for Kodak (the very large color displays in

Grand Central Station, New York City), as well as many advertising pictures for them. I did a lot of color of Yosemite and the National Parks and in Hawaii. I did relatively few for myself as I was not satisfied aesthetically with the results and, of course, had limited controls. Many of the Kodachromes made in the early and middle 1940s have lasted fairly well. The Ektachromes have all faded and are useless.

Everyone thinks I am negative to color. I am to most of the color I see; I have often said that the ordinary color print looks like a piano sounds if it is a little out of tune. What I was trying to convey is that the color values are "out of key;" the relationships of hue and value are not aesthetically satisfying. This is difficult to explain; I do not imply that color must be "realistic" (it cannot be — it can only simulate reality). I appreciate all efforts to establish a new color language. Many handsome images have been made in many different techniques. Color reproductions (lithographic printing, etc.) improve upon the original transparency or print in many cases; printing inks have a "pigment" feeling which I much prefer to dye quality. These reactions are, of course, personal, but many photographers share them with me.

From a letter to Peter Wensberg at Polaroid, "Tentative Analysis of the Proposed Work on Color," April 22, 1982

I can truthfully say I can remember only two or three color photographs that are worth remembering. There are thousands of paintings I can't get out of my mind. People are skeptical about my thoughts on color. I do not blame them, as I have protested it, and have not shown color pictures. I feel the urge now and only wish I was sixty years younger!

From a letter to Dennis Purcell, April 24, 1982

I am impressed and grateful for your offer to make a trial print of one of my transparencies. I have done no color of consequence for thirty years! I have a problem with color — I cannot adjust to the limited controls of values and colors. With black-and-white I feel free and confident of results.

However, I have done *some* color in the past which is acceptable. But most (about 98%) have faded. The Kodachromes have lasted best of all. I am perplexed over what to do about the good transparencies, as some are worthy of preservation.

I am sending a picture which was marvelous in its original qualities. It has deteriorated — but proportionally! It had a marvelous feeling of light. It has faded to the extent that the shadows have lower densities and have turned purple. The yellows are not quite as strong as they were. The aspen trunks are actually improved on the original rather greenish color they presented.

I am wondering if a print from this 8 x 10 transparency is possible? I shall not presume to advise you what to do — as I do not know myself — but I can suggest that the feeling of enveloping light is paramount. If you are interested in such a problem I shall be most appreciative. I cannot guarantee that I would approve of *any* print made from this transparency, but I shall certainly be interested in what you might be able to do with it. I wish you luck! And I appreciate your request to make a print for me.

Letter to Michael Wilder, September 30, 1983, about making a Cibachrome print. (See page 43.)

I have intended writing you personally since your visit but things have been a bit mixed up (as usual) and I failed to do so. I wanted to express my appreciation of the very fine job you did with my transparency. While I have

some high hopes for the benefits of "reconstruction" my main concern lies in the question: "Do I have enough fine images that deserve such treatment and possible use in a book." I have been very critical of my color work from a creative point of view — regardless of the technical qualities they might have.

Hence, I must go over them all with that question in mind — before you come to discuss them.... This meeting might be arranged in about a month. Do not plan on it as yet — much depends on my health, but I hope it can be arranged as soon as possible.

Letter to Michael Wilder, October 26, 1983, acknowledging receipt of the Cibachrome print made by Wilder from Adams' transparency. (See page 43.)

I fear I have become a problem!

I don't like photographic color.

I don't like the print of the Aspens.

It is not my dish of tea!

Wilder did a wonderful job of exhumation. But the whole idea is of increasing concern to me. While I did an awful lot of color when I was professionalizing, I never got anything that aesthetically pleased me. I know a lot about the mechanics — especially exposure and the application of the Zone System. The visual tests I had at Polaroid show that I have an excellent color perception over the full spectrum. I *wish* I liked it! Hence, while I have much that is going for color I find it is increasingly negative for me.

My field is B&W. I should stick to it!

If anyone thinks there is "hope" for my transparencies, let them fuss with them. I could do a paper on my practical theories that would help students. But it would be false to identify me *creatively* with photographic color.

I have MUCH to do to round out my B&W. Probably not as much time as I would like. I would rather encourage young people in color than try to flog my own into the world of attention. Most of the people who have seen the Wilder color print have expressed little enthusiasm — sometimes negative surprise.

It was a relief to take it off the wall!

I hope you understand.

Love and appreciation for your forward thinking!!

Letter to Mary and Jim Alinder, March 9, 1984, about the Cibachrome print made by Michael Wilder of Aspens, North Rim, Grand Canyon National Park, Arizona, 1947. *(See page 43.)*

List of Plates

Frontispiece: Detail of the Alaska Range, Denali National Park, Alaska, 1948 *(8 x 10-inch Ektachrome)*

Page

35 Half Dome and Clouds Rest, from Glacier Point, Yosemite National Park, California, 1949 *(8 x 10-inch Kodachrome)*

37 Autumn Forest, Yosemite National Park, California, c. 1946 *(4 x 5-inch Kodachrome)*

39 Detail, Pool, Tuolumne Meadows, Yosemite National Park, California, c. 1947 *(2¼ x 3¼-inch Kodachrome)*

41 Yosemite Falls, Yosemite National Park, California, c. 1953 *(8 x 10-inch Ektachrome)*

43 Aspens, North Rim, Grand Canyon National Park, Arizona, 1947 *(8 x 10-inch Kodachrome)*

44 Tree, Barn, Hills, near Livermore, California, c. 1950 *(4 x 5-inch Kodachrome)*

45 Green Hills, Evening, near Gilroy, California, c. 1945 *(5 x 7-inch Kodachrome)*

47 Mount McKinley, Grass, Denali National Park, Alaska, 1948 *(5 x 7-inch Kodachrome)*

49 Pool, Kaibab Plateau, Arizona, 1947 *(5 x 7-inch Kodachrome)*

51 Wainiha Bay, North Shore of the Island of Kauai, Hawaii, 1948 *(5 x 7-inch Kodachrome)*

53 Santa Elena Canyon, Big Bend National Park, Texas, 1947 *(5 x 7-inch Kodachrome)*

54–55 Landscapes, near Philmont, New Mexico, 1961 *(2¼ x 2¼-inch Ektachromes)*

57 Pool, Kaibab Plateau, Arizona, 1947 *(5 x 7-inch Kodachrome)*

59 El Capitan, Guadalupe Mountains National Park, Texas, 1947 *(4 x 5-inch Kodachrome)*

60–61 Waimea Canyon, Island of Kauai, Hawaii, 1948 *(5 x 7-inch Kodachromes)*

63 Clearing Storm, Yosemite National Park, California, c. 1950 *(4 x 5-inch Ektachrome)*

65 Lower Yosemite Falls, Yosemite National Park, California, c. 1946 *(8 x 10-inch Ektachrome)*

67 Upper Yosemite Falls, from Fern Ledge, Yosemite National Park, California, 1946 *(2¼ x 3¼-inch Kodachrome)*

69 Salt Pools, near Wendover, Utah, c. 1947 *(8 x 10-inch Ektachrome)*

70 Pool Detail, Yellowstone National Park, Wyoming, 1946 *(5 x 7-inch Kodachrome)*

71 Detail of Mammoth Pool, Yellowstone National Park, Wyoming, 1946 *(5 x 7-inch Kodachrome)*

73 Mono Lake, White Branches and Clouds, California, 1947 *(8 x 10-inch Ektachrome)*

75 Caladium Leaves, Foster Botanical Gardens, Honolulu, Hawaii, 1948 *(4 x 5-inch Ektachrome)*

77 Bad Water and Telescope Peak, Death Valley National Monument, California, c. 1947 *(8 x 10-inch Kodachrome)*

79 Vertical Cliff, Zion National Park, Utah, 1946 *(8 x 10-inch Ektachrome)*

81 From near Sandy Cove, Glacier Bay National Monument, Alaska, 1948 *(5 x 7-inch Ektachrome)*

83 Lone Pine Peak, Winter Sunrise, Sierra Nevada, California, 1948 *(8 x 10-inch Ektachrome)*

85 Wizard Island, Crater Lake National Park, Oregon, 1946 *(5 x 7-inch Kodachrome)*

87 Winter Forest, Fresh Snow, Yosemite National Park, California, 1948 *(5 x 7-inch Ektachrome)*

89 Ice Bow, Death Valley National Monument, California, c. 1960 *(2¼ x 2¼-inch Ektachrome)*

91 Mauna Kea from Mauna Loa, Hawaii, 1948
 (5 x 7-inch Ektachrome)

93 White Sands National Monument, New Mexico,
 c. 1947 (8 x 10-inch Kodachrome)

95 Manley Beacon, Death Valley National Monument,
 California, c. 1952 (8 x 10-inch Ektachrome)

96 Church, Sunrise, Front, Ranchos de Taos, New
 Mexico, c. 1948 (5 x 7-inch Kodachrome)

97 Church, Sunset, Rear, Ranchos de Taos, New
 Mexico, c. 1948 (5 x 7-inch Kodachrome)

99 Papoose Room, Carlsbad Caverns National Park,
 New Mexico, c. 1947 (5 x 7-inch Kodachrome)

101 Monument Valley, Utah, c. 1950
 (5 x 7-inch Kodachrome)

102 In Bryce Canyon, Bryce Canyon National Park,
 Utah, 1944 (4 x 5-inch Kodachrome)

103 Cliff Detail, Bryce Canyon National Park, Utah,
 1944 (4 x 5-inch Kodachrome)

105 Late Evening, Monument Valley, Utah, c. 1950
 (4 x 5-inch Kodachrome)

107 Autumn Forest, Twilight, Yosemite National Park,
 California, c. 1950 (5 x 7-inch Kodachrome)

109 Landscape, Fall, near Aspen, Colorado, 1951
 (8 x 10-inch Ektachrome)

111–113 The Grand Canyon, Grand Canyon National Park,
 Arizona, 1947 (8 x 10-inch Ektachromes)

115 Sunrise, Telescope Peak, Death Valley National
 Monument, California, c. 1952
 (8 x 10-inch Ektachrome)

TECHNICAL NOTE

Ansel Adams made color transparencies for more than
thirty years, but most of the images in this book were made
between 1944 and 1952. Adams used Eastman Kodak Com-
pany's Kodachrome and Ektachrome sheet film, in sizes
from 2¼ x 3¼ to 8 x 10 inches. To correct the changes in
color that have occurred over time, and to eliminate defects
such as dust spots, scratches, and vignetting, TX Unlimited,
Inc., of San Francisco, under the careful supervision of
The Ansel Adams Publishing Rights Trust, produced digital
transparencies from which the plates for this book were
prepared. No attempt was made to alter the images by dodg-
ing or burning. The images are presented full frame except
where defects along the edge were cropped, or, in the case of
the photograph on page 45, where Adams himself indicated
cropping. Adams' original titles were used, with slight clarifi-
cation if necessary. Dates were verified using Eastman Kodak
Company's film data (supplied by George Eastman House)
and by consulting Adams' correspondence.

ACKNOWLEDGMENTS

Many individuals have helped make this book possible. Pam Feld played a vital role in initiating the project. Harry Callahan took the time from his own already full life to travel to Carmel, California, to select the transparencies. Three eminent scholars in the photographic field shared with us their wise counsel: James L. Enyeart, Director, International Museum of Photography at George Eastman House, Rochester, New York; John Szarkowski, Director Emeritus, Department of Photography, the Museum of Modern Art, New York City; and David B. Travis, Curator, Department of Photography, the Art Institute of Chicago. TX Unlimited, Inc., of San Francisco produced the digital transparencies from which the plates in this book were made; we would particularly like to single out Matt Keefe, Jill Qualls, and John Vlahos for their tireless patience and expertise; and we also thank Judith Lichtman, Michael Osborn, Jeff Raby, Rob Sandusky, Susan Tallitsch, and Alson Tom. The New Lab, Calumet/LA, and Steve Johnson assisted with color reproductions and equipment. Peter Galassi, Director, Department of Photography, the Museum of Modern Art, New York City, Michael Wilder, and Wally McGalliard helped with the section of writings by Ansel Adams. Tim Waters allowed us to reproduce his father's snapshot of Adams, and the Center for Creative Photography supplied the negative. Bruce Campbell created the handsome design, and Acme Printing Company printed the sheets to our high standards. Little, Brown and Company's staff was indispensable: Charles Hayward, Terry Hackford, Janet Bush, Amanda Freymann, and Betsy Pitha. John Sexton and Alan Ross advised on the reproduction of the transparencies. The staff of The Ansel Adams Publishing Rights Trust, Phyllis Donohue, Rod Dresser, and Jeff Nixon, provided excellent assistance. Finally, we would like to thank Virginia Adams, who unstintingly shared her thoughts and hospitality.

J.P.S. and A.G.S.

DESIGNED BY BRUCE CAMPBELL

TYPESET BY PAUL BAKER TYPOGRAPHY, INC.

PRINTED BY ACME PRINTING COMPANY

BOUND BY ACME BOOK BINDING